WALWORTH REFLECTIONS

Darren Lock & Mark Baxter

AMBERLEY

First published 2022

Amberley Publishing
The Hill, Stroud, Gloucestershire, GL5 4EP
www.amberley-books.com

Copyright © Darren Lock & Mark Baxter, 2022

The right of Darren Lock & Mark Baxter to be identified
as the Authors of this work has been asserted in
accordance with the Copyrights, Designs and Patents
Act 1988.

ISBN 978 1 3981 0588 1 (print)
ISBN 978 1 3981 0589 8 (ebook)

British Library Cataloguing in Publication Data.
A catalogue record for this book is available from the
British Library.

Typesetting by SJmagic DESIGN SERVICES, India.
Printed in Great Britain.

Introduction

Amberley published our first book on this area – *Walworth Through Time* – in 2010. It therefore seemed to us like a good idea to mark that ten-year anniversary in 2020 with a look at the area ten years on. We were delighted that the publisher agreed.

So when we started compiling this book in January of that year, I think it's fair to say that not many of us had any clue as to what the rest of year had in store. Darren and myself started on our merry way and began to compile the photos and undertake our research. Only, just as we began to get into our stride, we were locked down due to the severity of a global pandemic.

All that we took for granted – going to work, visiting friends and family, drinking in pubs, eating out, even going for a walk – were now under strict measures.

It meant change, a lot of change, and it took a lot of getting used to. We quickly decided to carry on with the project, as safely as possible of course, and over the next twelve months that followed, we saw our 'manor' as we had never seen it before.

Now the area of Walworth, London, SE17, is ever-changing and it has been like that for many decades. But even these old streets hadn't experienced anything like this before. Shops closed, with some never to return. The multitude of building sites always around us just stopped, for a while at least.

East Street market fell eerily quiet and the numerous, always busy, food establishments serving up cuisine from all corners of the planet served no more. Months of lockdown continued and still we battled to complete the book.

Our aim with it is to compare 'old' Walworth with the fast-emerging 'new' Walworth – a vibrant melting pot of cultures and classes living cheek by jowl amid rapid regeneration of an often-undervalued part of London.

One thing for certain in the early 2020s is that the area is undervalued no more. Over the past five years, town planners have seen the potential of what encompasses Elephant and Castle on the northern border of Walworth, and a new large retail space and leisure area, named Elephant Park, is now beginning to make its way down to reach the main part of the Walworth Road.

As we write this introduction in May 2021, the Elephant shopping centre has closed its doors for the last time and is currently being demolished, as have a few other buildings in this book.

A third national lockdown is just ending and Covid-19 is still very much to the forefront of many minds, though with millions now getting vaccinated there is hope that life will be getting back to normal fairly soon.

Someone once said 'may you live in interesting times'. I think we can all cross that one off.

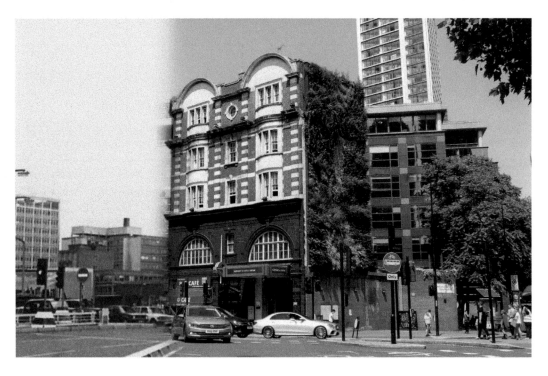

Elephant and Castle Tube Station/South London Press
High-rise offices and apartments now surround this building, which was opened in 1906. Once known as the Bakerloo and Waterloo railway station, it services the Bakerloo and Northern tube lines. Art noveau in style, it was designed by the celebrated architect Leslie Green. It was once also home to local newspaper *The South London Press*, founded in 1865. The newspaper is still in operation, now with offices in Charlton.

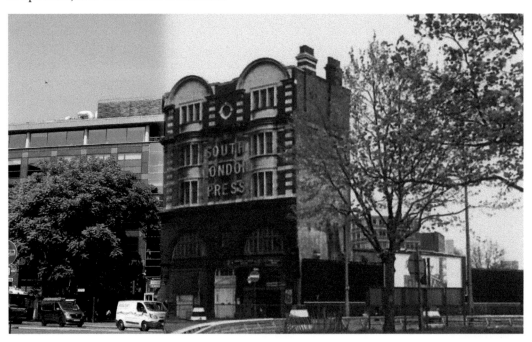

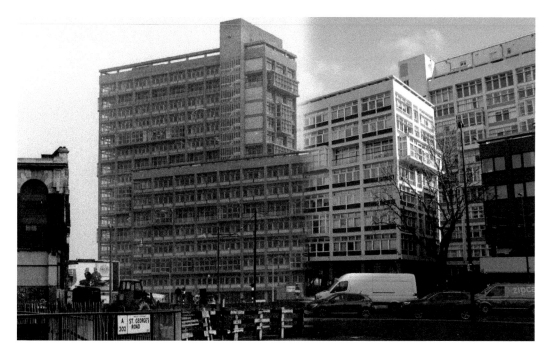

Alexander Fleming House

The work of Hungarian architect Erno Goldfinger (1902–87), this group of seventeen-storey buildings from 1960 was considered of high merit when completed. Brutalist in style, the Ministry of Health set up offices here and named them after the pioneering Sir Alexander Fleming, who discovered penicillin in 1928. However, they were converted to 400 apartments in 1988 after the Ministry moved and were then named Metro City Heights. The James Bond author Ian Fleming so detested the work of the architect, he decided to name his villain in the films after good old Erno.

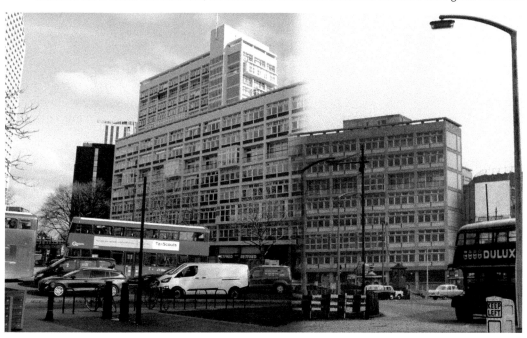

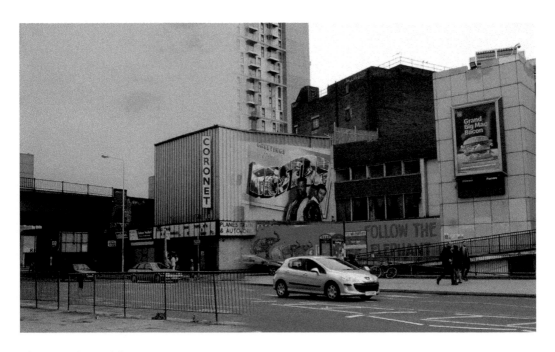

The ABC Cinema/The Coronet

Many locals of a certain generation will remember joining a queue to see the latest blockbuster film at the ABC Cinema situated at Nos 24–28 New Kent Road. It was originally named the Elephant and Castle Theatre, opening in 1879. A rebuild in an art deco style in 1932 saw it reopen as a cinema. The building was then renamed the ABC Cinema in 1967, and covered with a blue cladding. In 1986 it became the Coronet Cinema until that closed in 1999. In recent years it has been a live music venue. The building was closed completely in early 2018 and its demolition is under way, despite a very active campaign to try and save it.

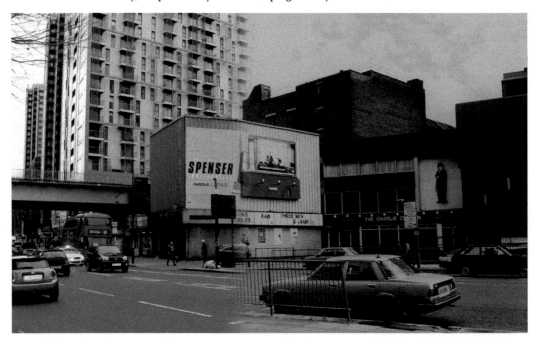

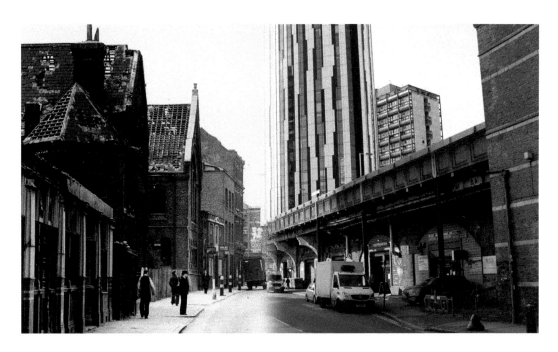

Elephant Road

Looking towards Walworth Road directly behind what was once the Elephant and Castle shopping centre, the buildings on the left in this photograph from the mid-1950s have all been demolished and that area now forms part of Elephant Park. An entrance to the Elephant and Castle railway station is situated to the right. The station, with its brick viaduct, was opened in 1862. Various small businesses trade from within the 22-feet-high and 25-feet-wide railway arches either side of the station. Among them are Corsica Studios, an independent arts space and venue; and the Re-Cycling second-hand bike shop, as well a couple of South American cafés serving the thriving Colombian community of the area.

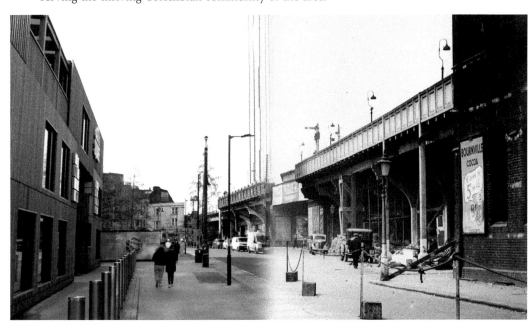

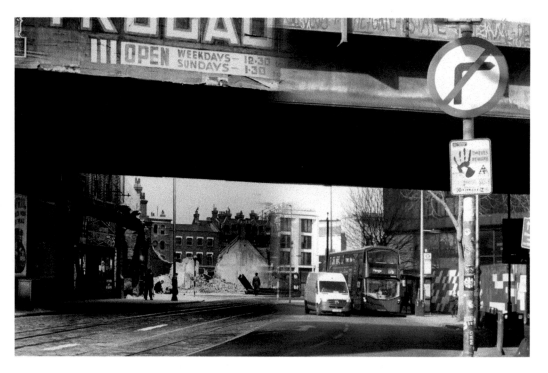

The Railway Bridge.
Looking through and under the bridge, the massive redevelopment of the Elephant and Castle area can be seen being undertaken. An advert for 'The Troc', the cinema that seated 3,000 people, can be seen affixed to the bridge.

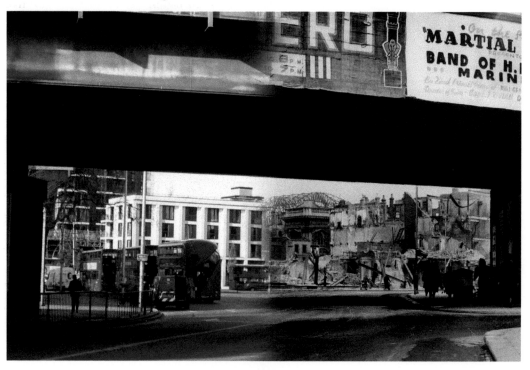

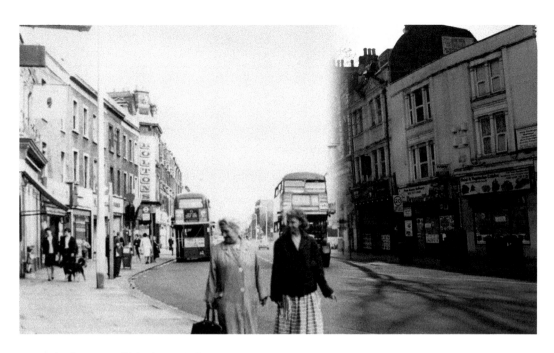

Elephant Road/Elephant Park

Looking down from the Elephant and Castle, the majority of shops and flats on the left-hand side of the road in the photograph from 1967 were demolished to make way for the Heygate Estate development in the late 1960s. This in turn is now called Elephant Park. Across the road on the right-hand side, the majority of these late nineteenth-century buildings remain intact. The shops there now are mainly food outlets. At Nos 80–82 stands the popular The Ivory Arch Indian restaurant. The Electric Picture Palace cinema, opened in 1910 at No. 88, is now flats. Further left, the light blue paintwork identifies Julian Markham House at No. 114. This provides accommodation for those studying at the various local art colleges. The Dragon Castle Chinese restaurant forms the lower part of this building.

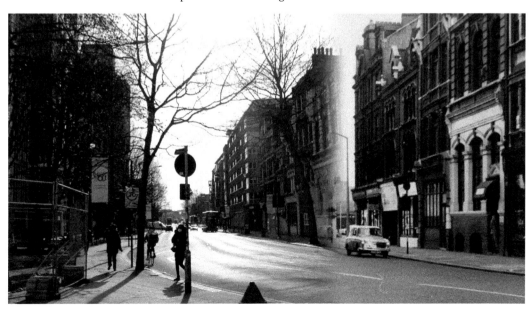

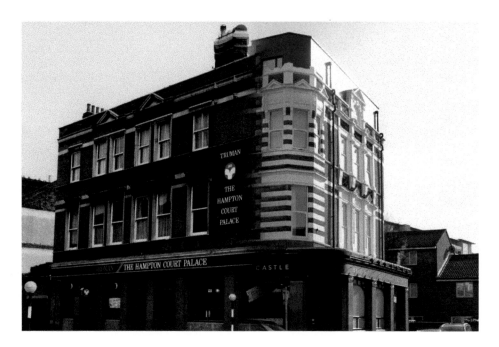

The Hampton Court Palace

This imposing and impressive mid-nineteenth-century pub, with its name carved in stone at the highest point of the building, once had a hall that could seat 100 for dinner. Members of the 'Odd Fellows' societies of the day would regularly meet there. Somewhat off-the-beaten track, it is situated near the Newington Estate, at No. 35 Hampton Street. Over the years it has had a fine reputation for its food and the live entertainment it provided, with a succession of singers and bands performing the hit songs of the day on most nights. And yes madam, the 'house' band went by the name of The Swinging Hamptons'. It is now part of the Brit Hotel chain.

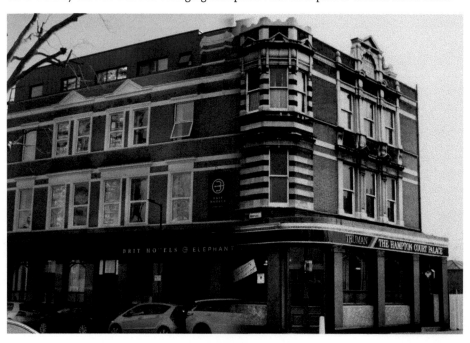

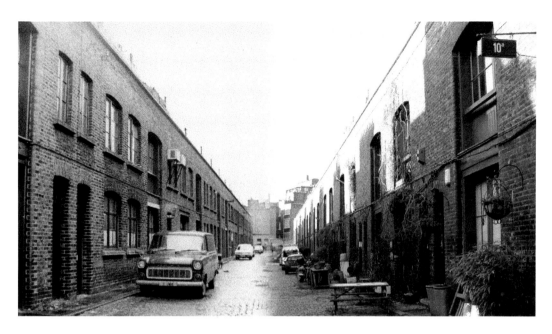

Iliffe Yard

After years of neglect by Southwark Council, new craftsmen moved into the workshops that had been once abandoned on this picturesque yard, not far from the Elephant and Castle. Painters, silversmiths, ceramicists, bookbinders and filmmakers work there to this day. This was all part of the 'Pullen Building' project undertaken by local builder James Pullen, who purposely built work yards alongside the original 650 flats built in the late nineteenth century. Their occupants back then would comprise of seamstresses, candle makers, hansom cab drivers and many other tradesmen, now long lost to time. Open days are held every year at the yards, where members of the public can visit the studios and buy directly from the artisans.

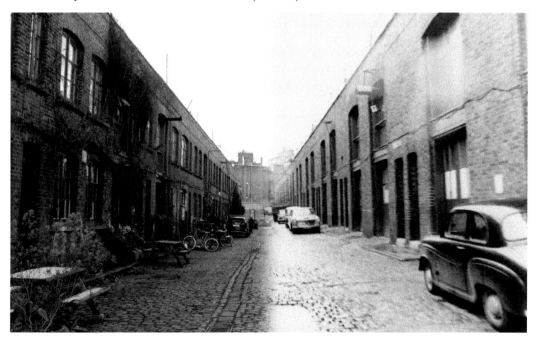

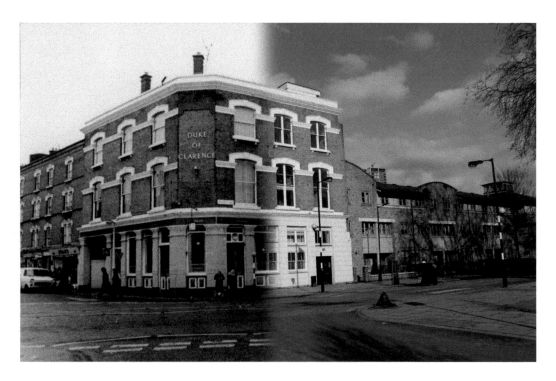

Manor Place/Penton Place

The Duke of Clarence pub once stood here and was home from 1895 to the Lynn Amateur Boxing Club, which continues to be the UK's longest surviving club, now situated on Wells Way in SE5. The pub, when closed down, became Duke of Clarence Court in 2005. The Duke of Clarence Estate is on either side, where part of the Pullen's tenement blocks once stood.

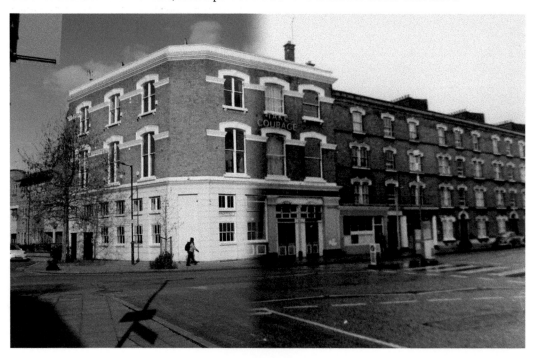

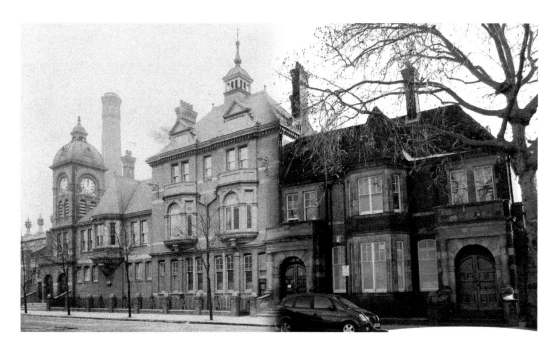

Manor Place Baths

This Grade II listed building was opened on 16 March 1898, built at a cost of £60,000 from a design by E. B. L. Anson. The sepia photograph was taken not long after in 1910. It contained a public washhouse, a laundry and swimming baths. Generations of Walworth residents used the facilities, encouraged to do so to maintain personal hygiene. There were three pools in total. The halls were also used for civic and social functions, as well as staging other sporting occasions with boxing particularly popular, both amateur and professional. Southwark Council was closed it in 1978, claiming the baths were now dangerous to use. In recent years, it has been home to a Buddhist group and a recycling yard.

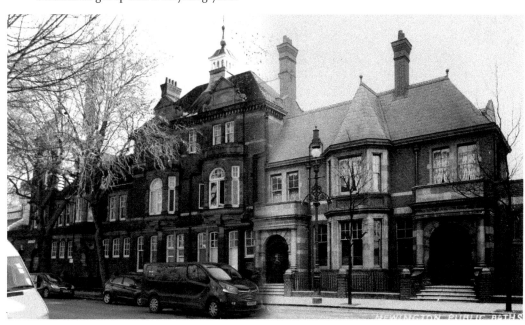

Braganza Street

The Walworth Territorial Army centre stands at No. 71 Braganza Street. It is home to A Squadron, General Support Medical Regiment, RAMC, which is part of the 256 Field Hospital. It is also home to the army cadets of the 73 and 75 detachment. The Surrey Rifle Volunteer Corps were once based here, and they later amalgamated into the Queen's Royal Surrey Regiment, so named in 1661 in honour of Catherine, Infanta of Portugal, who became Queen Catherine of Braganza after marrying King Charles II in Lisbon in 1662. The Paschal Lamb, the badge of the regiment, is stone cut into the white arch on the left of the building above the doorway.

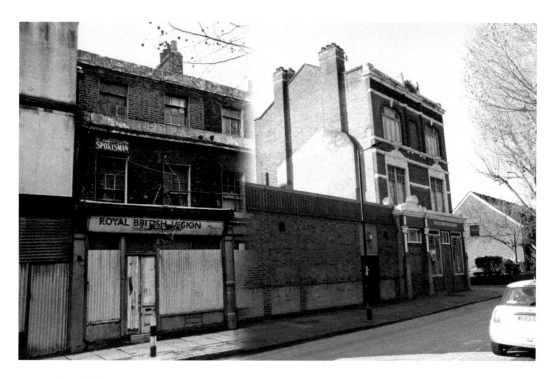

The British Legion

Situated at No. 34 Braganza Street and seen here in the *c.* 1978 sepia photograph, this was once The Royal George pub. The 'Legion' moved over from the buildings on the left in the 1980s. The British Legion itself started in 1921 and its aims were to provide care, support and to campaign on behalf of ex-British Armed Forces personnel and their families. It was granted a royal charter in 1971 to mark its 50th anniversary and is best known for its Poppy Appeal each year.

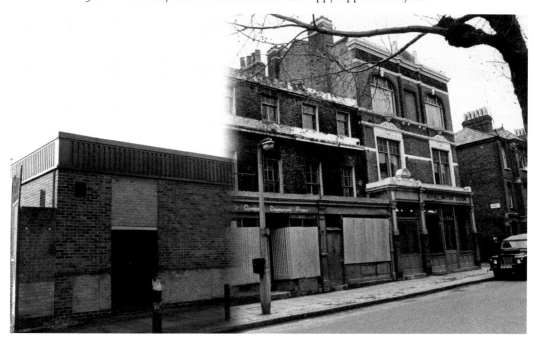

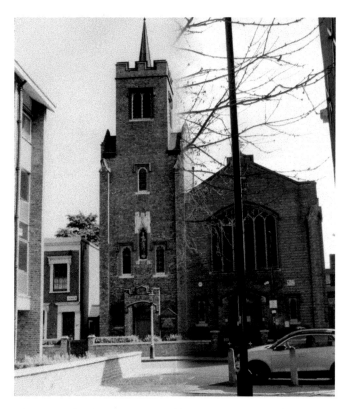

St Wilfrid's

Found at No. 97 Lorrimore Road, this imposing structure was designed by Frederick Arthur Walters (1849–1931), a Scottish architect noted for his work on over fifty Roman Catholic churches. The clergy house adjacent to the English Martyrs Church on Rodney Road is also the work of Walters. St Wilfrid's was built in 1914 in Perpendicular Gothic style in red brick with a 60-foot tower topped by a small spire. It suffered bomb damage in November 1940 and was restored between 1948 and 1949. Further work was undertaken from 1957 to 1959 and Bishop Cyril Cowderoy consecrated the church in the summer of 1960. The church continues to serve the people of Kennington and West Walworth.

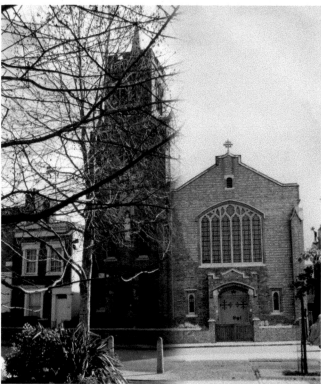

John Ruskin Street

Once known as Beresford Street, its name was changed in 1937 in honour of Ruskin, the celebrated writer and art critic from the Victorian era. The school standing proudly in each photo is John Ruskin Infants' School, built as part of the London School Board initiative from 1870 to build places of learning for the poor areas of London. One famous ex-pupil was Sir Michael Caine – not a lot of people know that.

Clubland

'The greatest youth club of all time', as many of those who went there would say, was situated at No. 54/56 Camberwell Road. It was opened by Queen Mary in 1939 and ran until 1977. It was founded by Revd Jimmy Butterworth, who arrived in Walworth in 1922. Jimmy was a master of raising funds for his club and over the years, many celebrities passed by to lend their support, among them Bob Hope, Laurence Olivier and John Mills. While visiting the club with his father, then the US Ambassador to the UK, a thirteen-year-old Bobby Kennedy gave his first ever speech to those who had gathered. Local lad Maurice Micklewhite took his first acting lessons there and did okay as Michael Caine a few years later. The Walworth Methodist Church, which today uses the buildings, is thriving with a healthy congregation.

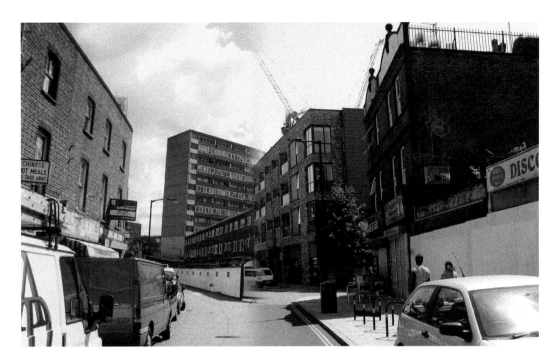

Westmoreland Road I

Looking down towards the bottom of Westmoreland Road from the Walworth Road, you can see clearly in the sepia photograph the Aylesbury Estate housing blocks, once part of Europe's largest housing development. The current building work will be continuing for some time. For this part of the development, 850 homes were created in the space created and the area was renamed Albany Place.

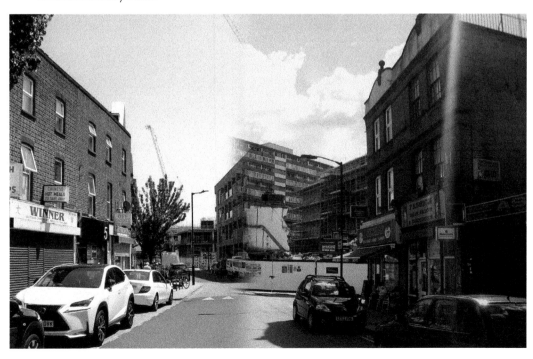

Westmoreland Road II

This road was famously once home to a thriving Sunday morning bric-a-brac market. 'Totters' from all over London would pitch up selling their wares of 'rag bone and lumber'. The market is now long gone, along with equally famous names such as the Sea Breeze chippy (now trading as the fine Ocean Fish Bar) Cockney Rebel, who sold the best in kids clobber, and Bri Line mini cabs, owned by local legend Ronnie Ruddock. Arments Pie and Mash is still there though and trading 106 years after first opening.

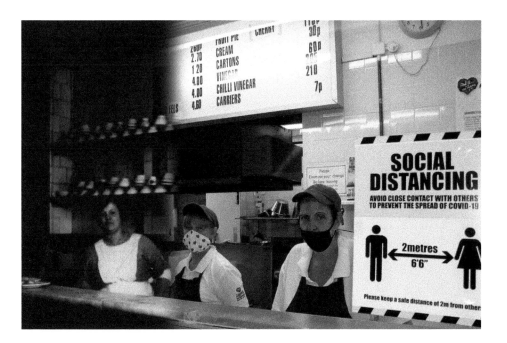

Arments Pie and Mash Shop

Without a doubt, this shop is a cornerstone of the area of SE17. Emily Evans married William Arment and the Arment family gradually took over the Evans business and the supply of handmade steak pies has been flowing ever since. Originally based at 386 Walworth Road, it has been at its current location of 7-9 Westmoreland Road since 1979. In 2014 as part of its 100th birthday celebrations, the borough of Southwark presented the business with a blue plaque as voted for by the people of the area. It is still run within the family, with Roy, Cheryl, Lorraine and Paul all playing a part in its continuing story. This now includes a very successful online operation, which has now taken over part of the shop, which proved essential, especially during the year of Covid-19 restrictions. Long may it reign!

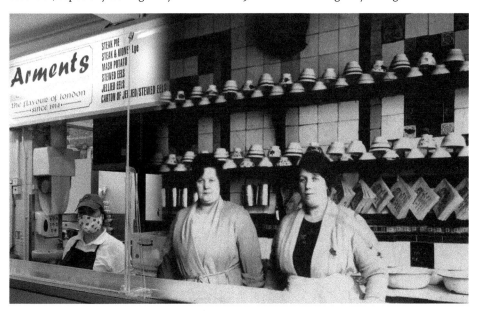

Merrow Street

Here, hundred-year-old houses stand next door to old industrial units, new builds and huge old warehouse spaces. The sepia photograph shows many houses boarded up and empty. Thankfully, as can be seen, they survived. In the summer of 2020 this became part of Low Emission Neighbourhoods scheme, which sprung up to encourage cycling and lower air pollution. Traffic chaos ensued leaving many local businesses residents baffled with others, like cyclists applauding the initiative.

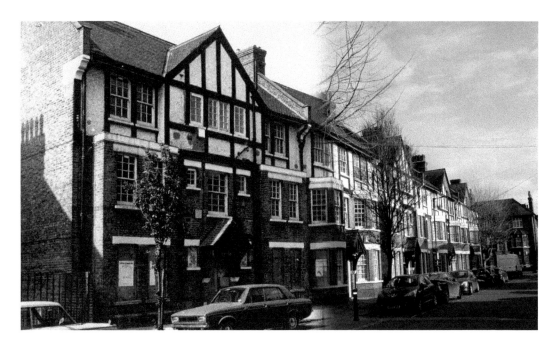

Liverpool Grove

Located to the east of Walworth Road, and west of nearby Dawes Street, Liverpool Grove is part of the Octavia Hill Conservation Area. Consisting of two- and three-storey tenements and flats in a cottage style, the buildings were part of an affordable housing scheme pioneered by social reformer Hill, who was later a founder of the National Trust. A significant building close by is St Peter's Church designed by Sir John Soane and built between 1823 and 1825.

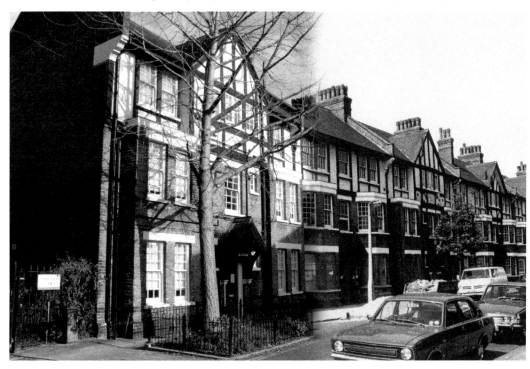

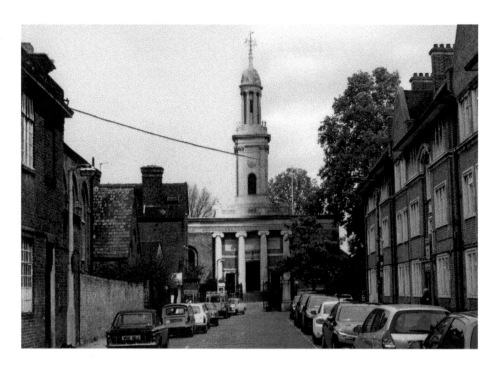

St Peter's

Looking at St Peter's Church, down Liverpool Grove, from the Walworth Road, the impressive architecture never fails to impress. Designed by Sir John Soane, work began on the building in 1823. A small children's zoo also once stood in the churchyard, created by Canon Horsley at the end of the 1800s. He also cleared the crypt at that time to create space to serve free meals to the pupils of St Peter's School, which had been built in 1835. The coffins that were removed were taken to Woking cemetery. The Ecclesiastical Commissioners of England built the housing block on the right in 1842.

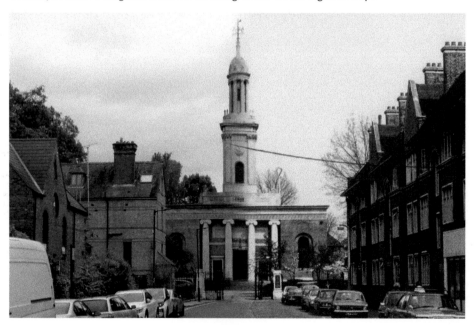

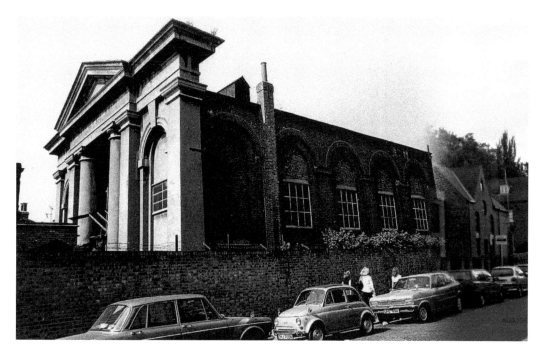

Sutherland Chapel

This was built in 1842 to house the congregation of Dr Edward Andrews, the minister of a chapel on nearby Beresford Street that was later renamed John Ruskin Street. This chapel was closed in 1904 and became the Electric Theatre Picture Palace. It is now luxury flats. It's always pleasing to see the original mock-Tuscan façade of portico and pediment still intact.

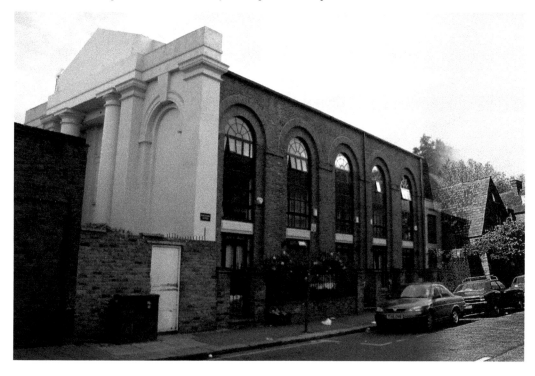

Sutherland Square

Lying back from hustle and bustle of the Walworth Road is the charming Sutherland Square. These very sought-after properties form a conservation area, covering parts of nearby Fielding Street, Lorrimore Square and Lorrimore Road. There is a communal residents garden at its heart, surrounded by the buildings, many of which are now fully restored to their former glory.

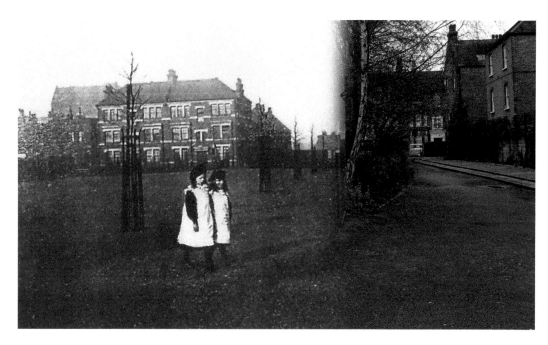

Faraday Gardens

Once Church Commissioners' land, Faraday Gardens began its life here in July 1905, after being 'gifted' to the local community. It is named after Michael Faraday, the eminent scientist, who was born not too far away in Newington Butts on 22 September 1791. It is home to the Walworth Festival and 'fun day' each summer.

Wooler Street I

In 1905 the celebrated social reformer Octavia Hill persuaded the Church Commissioners, who owned the land here, to provide poor of the area with good social housing. As a result, over 20 acres of slum land was transformed to provide decent housing stock, much of which remains to this day. All was tranquil until the Church Commissioners then sold the properties to the Genesis Housing Group/Grainger Trust in 2006, resulting in properties being sold off and increased rents placed on many of those that remained.

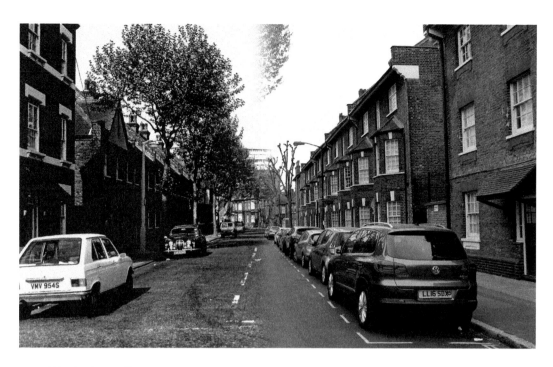

Wooler Street II

Despite a constantly changing landscape, there are still opportunities to see parts of Walworth that are relatively unchanged, as in this example, Wooler Street. The only marked difference in these two photographs is perhaps the make of cars on show and the 'bike hangar' on the left. The 'cottages' were part of the Octavia Hill estate as described earlier.

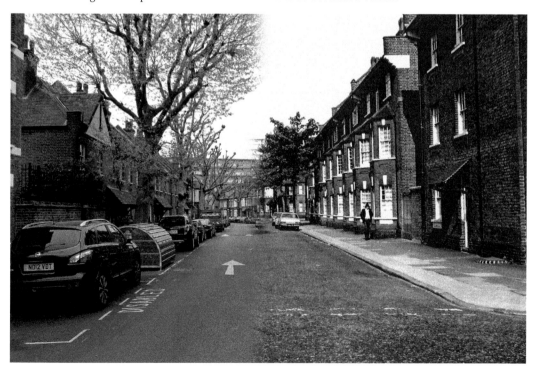

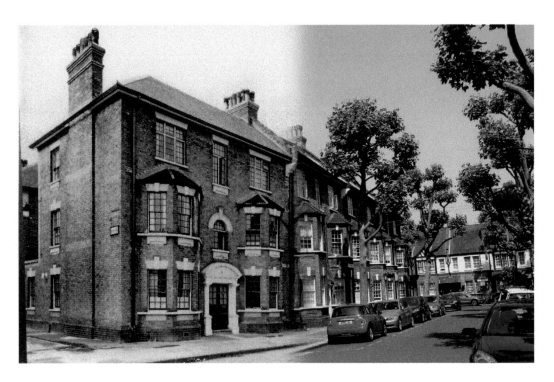

Villa Street

This street is also part of the Octavia Hill Conservation Area, and is made up of roughly 600 dwellings. Rising from slums, it provided very decent housing for local people. Looking at the two photos, again, it is clear to see it is remarkably untouched, whilst all around has been demolished, rebuilt, demolished and rebuilt once again.

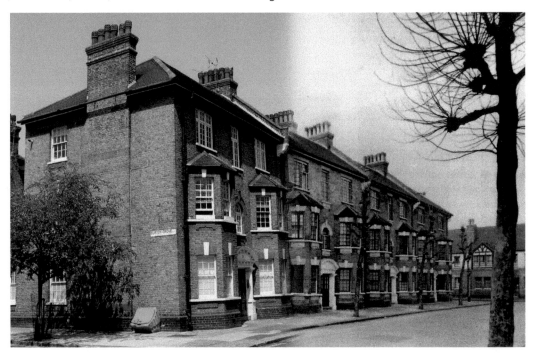

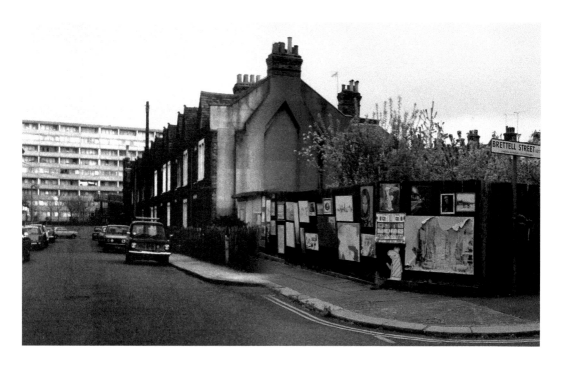

The Prefabs of Brettell Street

Prefabricated Sectional Bungalows or Prefabs to you! A classic example can be seen standing here on the corner of Brettell Street *c.* 1975. They were mainly built on old bomb sites as temporary accommodation and were meant to last only ten to fifteen years. Many of course lasted much longer than that, and were in many cases much loved by those who lived in them. By around 2010, many of the remaining structures were being demolished. We now have a 'pop-up' art gallery on the hoarding surrounding where they once stood.

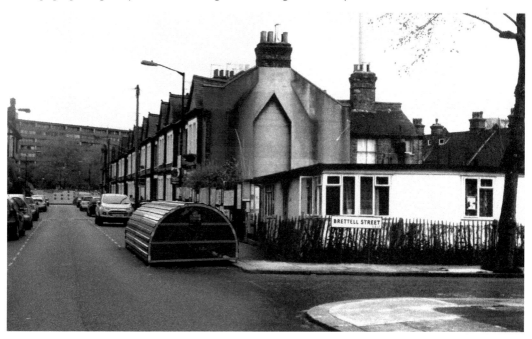

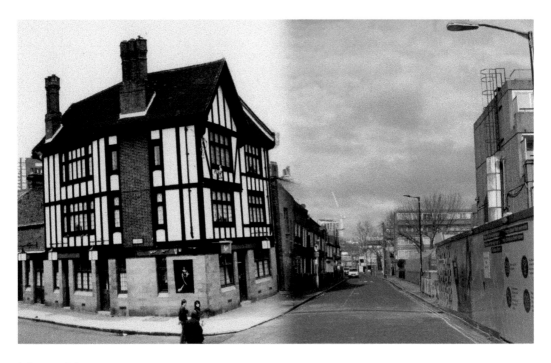

'The Annie'

Known affectionately by the locals as 'The Annie', this mock-Tudor pub could be found at No. 126 Dawes Street. Overshadowed for many years by the Aylesbury Estate, it is still standing and now known as the 'Old Queen Anne House', having been converted into private flats in the last ten years or so.

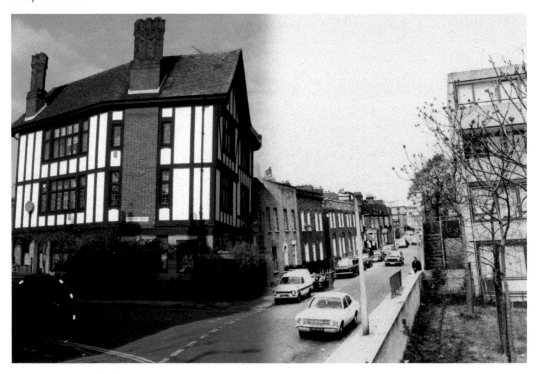

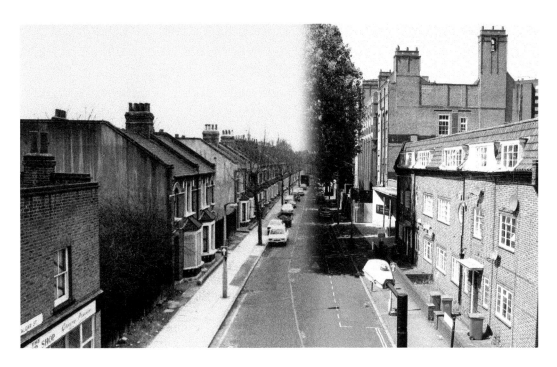

Trafalgar Street I

The overhead sepia photograph from 1963 shows a street named in honour of Nelson's victory at the Battle of Trafalgar of 1805, when the British defeated the combined efforts of the French and Spanish in a sea battle. During the First World War, over 300 men volunteered for service from this one street alone. A shrine was later erected to pay tribute to the eighteen of that number who never made it home.

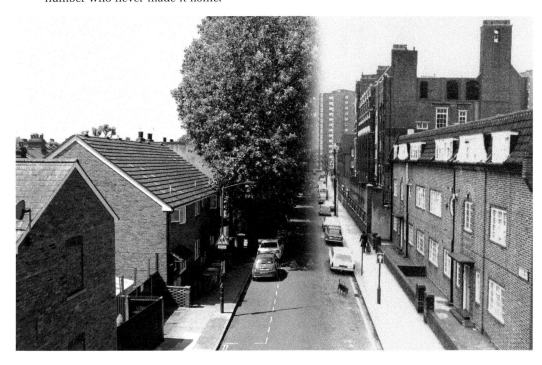

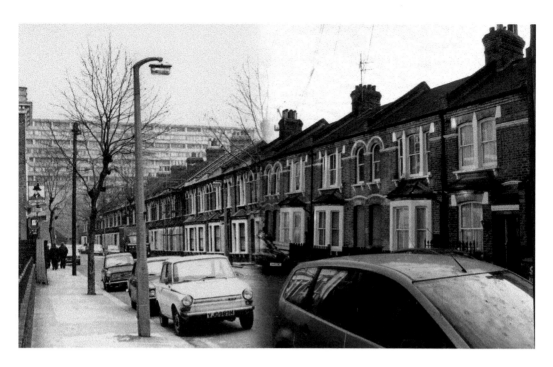

Trafalgar Street II

The sepia element of this photograph from the 1970s shows much of the housing stock boarded up and looking prime for the demolition boys, who had had a field day in this part of SE17. Thankfully, as can be seen, they survived and the area is so much the better for that.

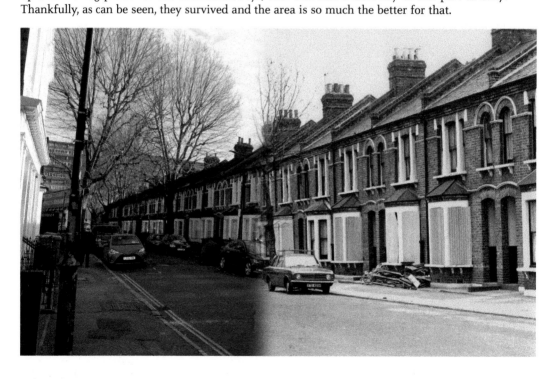

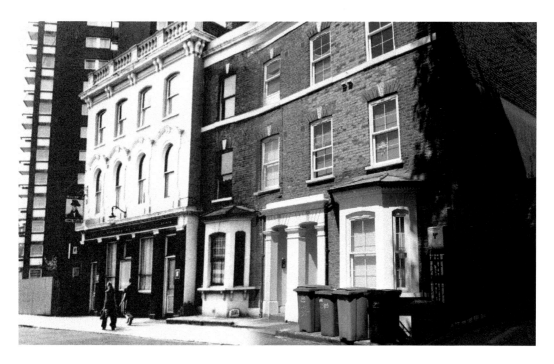

The Lord Nelson

Is there a higher accolade in life than having a pub named after you? Your authors think probably not. The Lord Nelson was once situated at No. 137 Trafalgar Street – where else? Michael William Davies is named as the victualler in residence here as far back as 1825, and the 1852 building shown in the sepia photograph retains many of it Victorian features. This Courage pub was closed in 2011 and was converted into luxury flats.

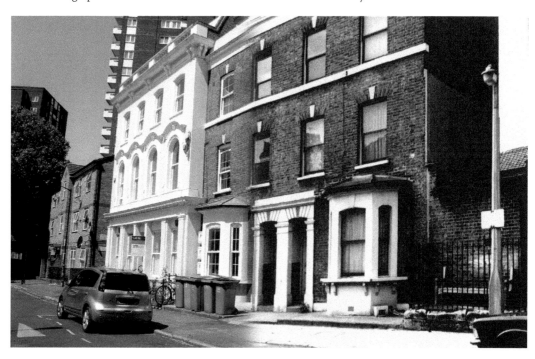

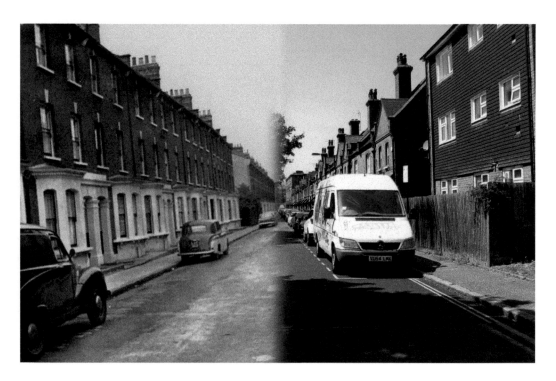

Date Street

The sepia photograph of Date Street is dated 1964. The housing stock on the right has changed very little since then. It runs parallel with East Street market, with the majority of it facing Faraday Gardens. At one end, it runs into Blackwood Street, which in its heyday was a thriving flower and plant market, of which a few stalls remain in 2021.

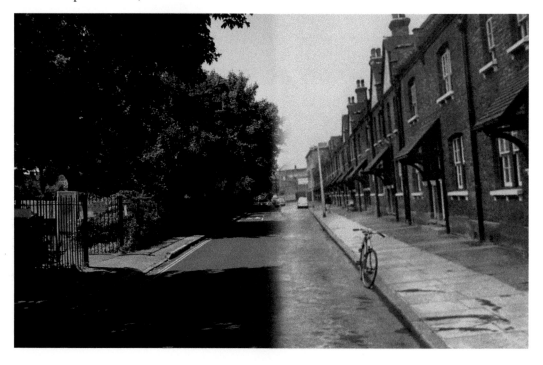

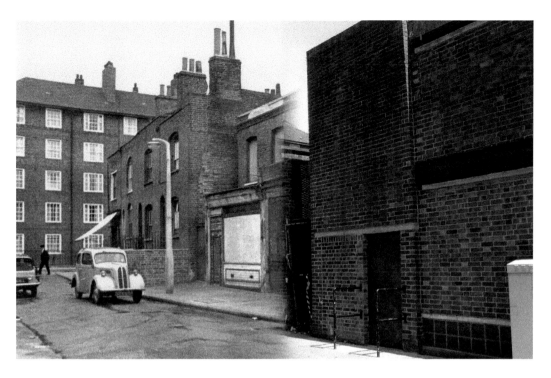

Blackwood Street

There has been a 'root market' on this backwater road for as a long as any of the old-time residents of SE17 can remember. For six days a week, very little happens here, but on most Sundays, you will still find a few stalls selling plants and shrubs to the local old and new gardeners of the area.

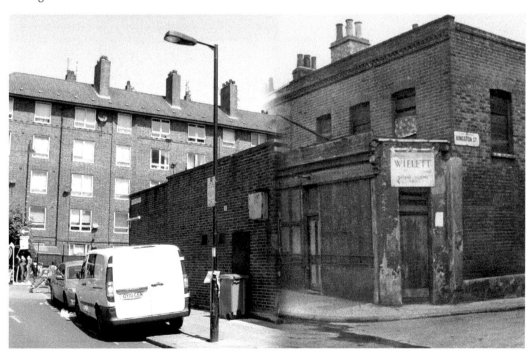

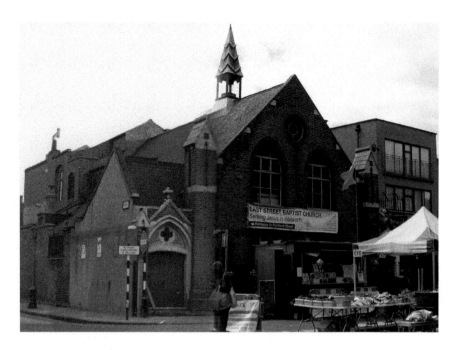

East Street Baptist Church

The foundation stone for this building at No. 177 East Street was laid by Princess Christian, daughter of Queen Victoria, in 1859. Once known as the Richmond Street Mission and Ragged School, it later became the East Street Mission and is now the East Street Baptist Church, described as an independent Bible-believing and teaching fellowship. It still retains a healthy congregation, and has been active in Walworth for over 150 years. Although it was closed for much of the Covid-19 lockdown periods, sermons continued online.

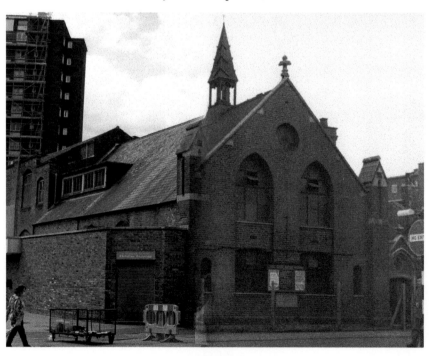

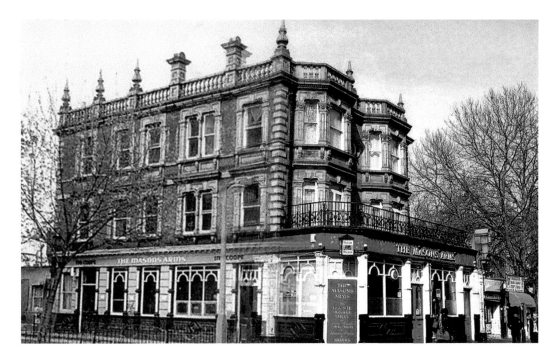

The Masons Arms

This can be found at No. 109 East Street. Constructed in 1989, it was once a fondly remembered 'market' pub, being situated on the once thriving East Lane market. The original photo is from 1977, around the time the local strippers there proved a very popular attraction. The stone carvings, which can still be seen high up on its frontage, depict tools of the mason trade, hence its name. The pub is closed presently, its fate to be decided.

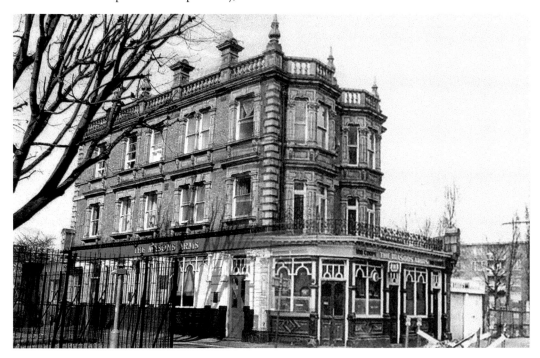

Dawes Street

Here on the corner of No. 153A East Street, Dr Charles Vickery Drysdale opened his first birth control clinic. The advice given to local women from here was valued as an enormous help, as many were living in terrible conditions, with large families with very little money coming in. Drysdale went on to found the Family Planning Association in 1930. His work here is recognised by an English Heritage blue plaque. The building itself has undergone a welcome renovation and is now back to residential dwellings.

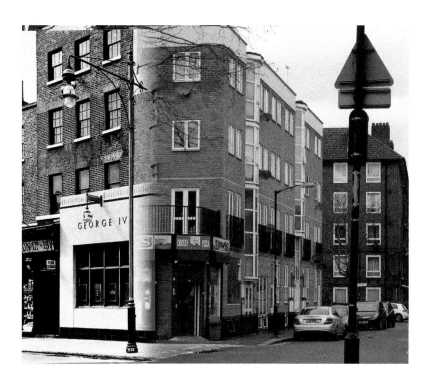

The George IV

Looking every inch like the top of an ocean liner from the 1930s in the sepia photograph, this was a well-loved Charringtons pub situated at No. 153 East Street. The first pint was pulled in 1869 by its first landlord, Mr Thomas Taylor, and the last there in 1995. Later demolished, there now stands a Kings chicken and pizza takeaway establishment, with flats taking up the rest of the building space.

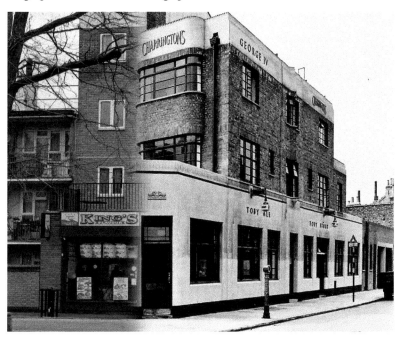

Deans Buildings/Orb Street

The building on the far right-hand side on the sepia photograph from around 1971 was The Prince Regent pub, once a Truman 'house', which was modern in appearance having been built in the late 1930s. Orb Street itself runs across both photos and behind that is now Nursery Row Park.

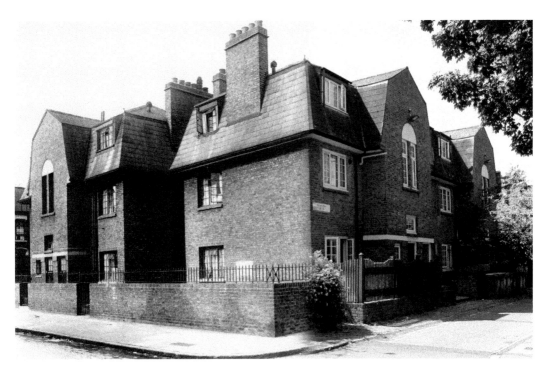

Orb Street

The advanced, almost modern design of these particular buildings shows up markedly, especially when compared with the gent in the cloth cap (below), looking somewhat confused by them in the black and white photograph. In many ways, they are very reminiscent of the new builds currently going up locally in 2021.

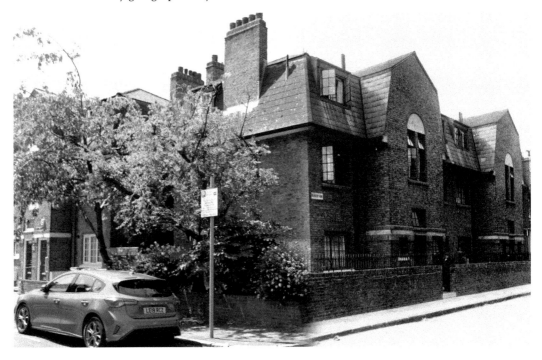

Brandon Street

The housing stock survives, with just the old wooden fencing now missing. Car parking spaces, as always, are obviously at a premium. One sad loss in recent years from the street is The Crown pub, now replaced by – yes you've guessed it – a small block of apartments.

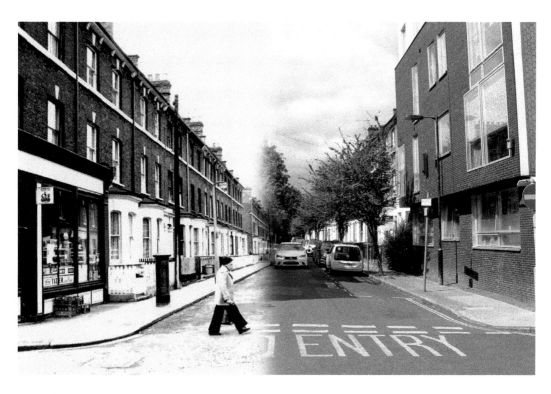

Charleston Street

Running off Brandon Street with Victorian terrace houses on its left, in this quiet backwater part of SE17. The sepia photograph is mid-1970s. The newsagent/sweet shop is long gone and the fancy tiled new build is by Quadrant Housing.

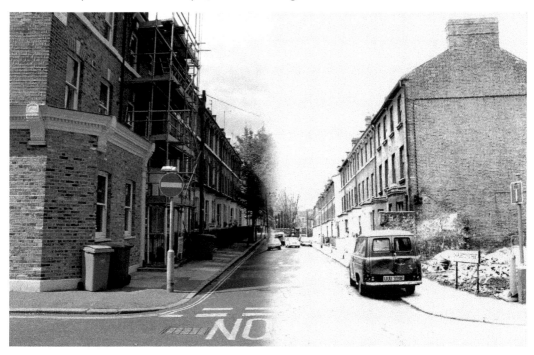

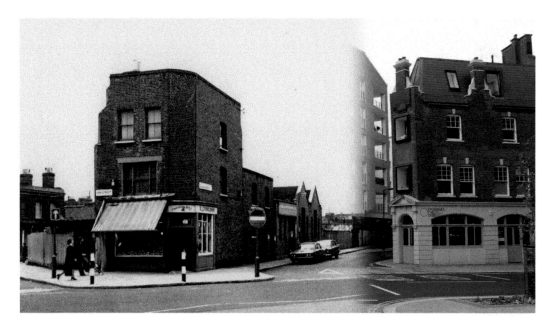

Rodney Road I

The 'Rodney' who gave his name to this road was the son of Edward Yates, a family surname that still own and run large section of property in SE17 to this day. The sepia photograph dates from *c.* 1978. It shows on the left local butchers, which has long since gone and is now home to the English Martyrs Church Hall, with apartments above. There is a Roman Catholic church of the same name just a few hundred yards further up and on the right. At No. 96 where The Rose & Crown pub once stood in 2015, there is now a popular independent wine bar, café and grocery named Diogenes the Dog.

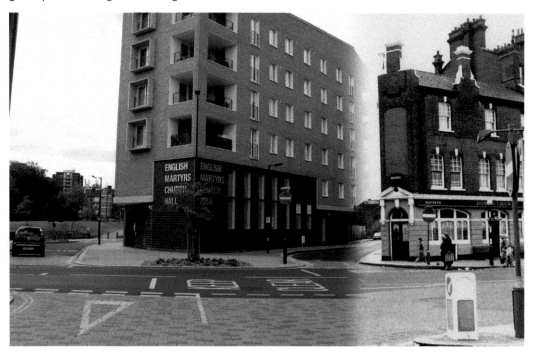

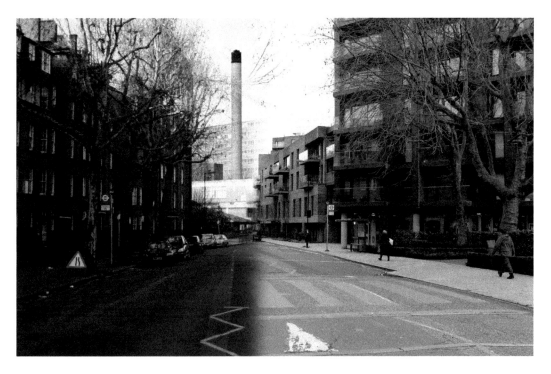

Rodney Road II

The 'before' photo here shows walkways onto the Heygate Estate from Rodney Road. These have all gone now, replaced with new builds from the development company Lend Lease as part of the massive regeneration in this particular part of SE17. The Heygate Estate was constructed in the 'Brutalist' style and completed in 1974.

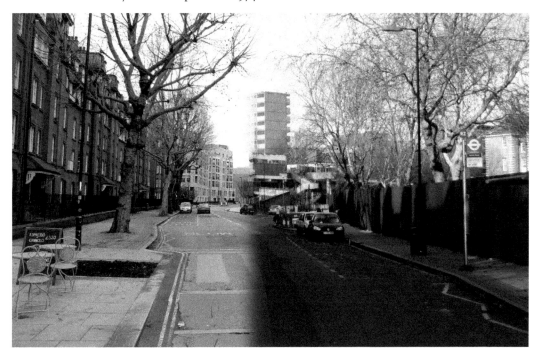

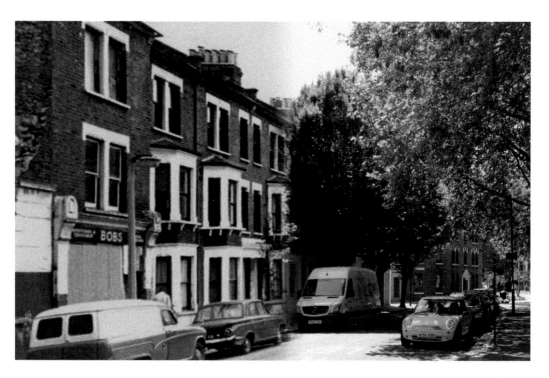

Balfour Street I
Situated on the fringes of the new Elephant Park development currently going up in place of the Heygate Estate, Balfour Street has retained a pretty good level of old housing stock, despite all the changes going on around it. Whether the two old ladies pictured would recognise much now, however, is debatable.

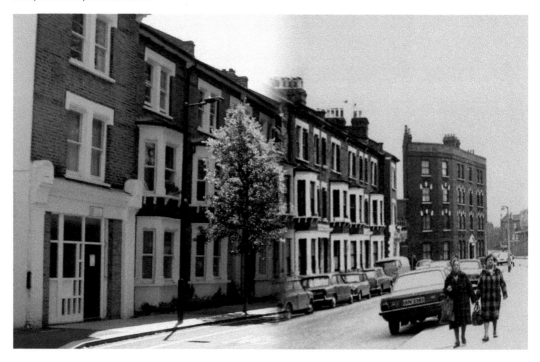

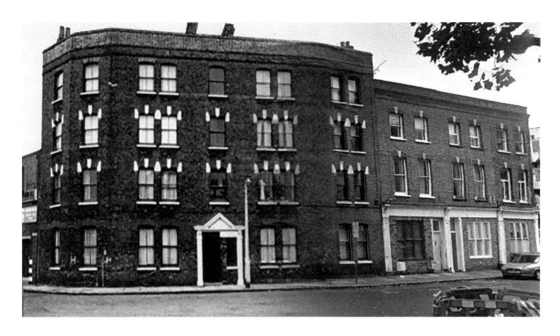

Balfour Street II

This nineteenth-century terrace, which accounts for Nos 67–81 Balfour Street, fell into a bad state in the early 1970s as its owners, Southwark Council, considered demolition. However, two tenants proposed to run the property as a housing co-operative. In 1976, as negotiations continued, the tenants and friends started to restore the properties. A meeting room was constructed and for many years it has been hired by organisations ranging from CND to Alcoholic Anonymous. Gardens were constructed on nearby wasteland in 1980. The Balfour Street (Housing) Project Ltd continues to this day, with twenty-one units and the community room.

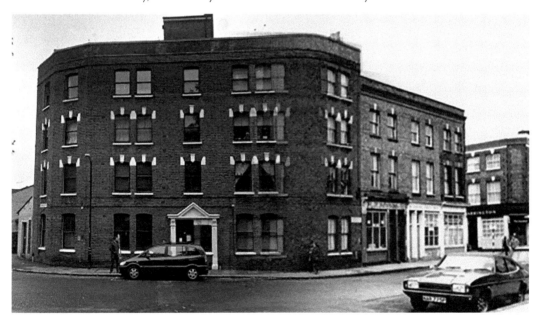

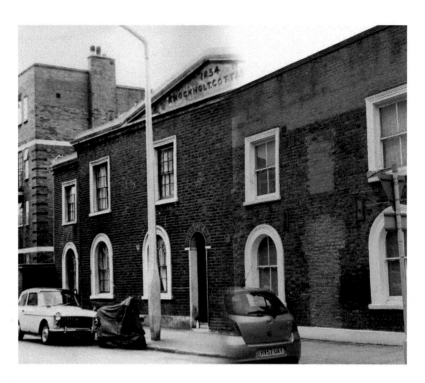

Elsted Street

Thankfully escaping a 'rearranging' either by the hands of the Luftwaffe during the Second World War or the London town planners of the 1960s, the cottages of Elsted Street remain pretty much intact. Built in 1854, they have, though, lost their impressive pediment and doors and windows have been 'bricked up'. Intriguing...

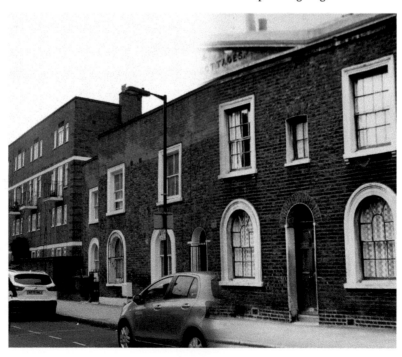

The Victory
Dramatic changes to the drinking culture of the vast majority of this area has changed enough for a plethora of backstreet pubs, like the one-time ornate Victory, seen here in the 1930s, to have closed their doors for good and be converted into one- and two-bedroom housing. Standing on the corner of Catesby and Barlow Street, this one-time Courage pub, named after Nelson's ship, HMS *Victory* and built in 1852, shut its doors for the last time in 2011.

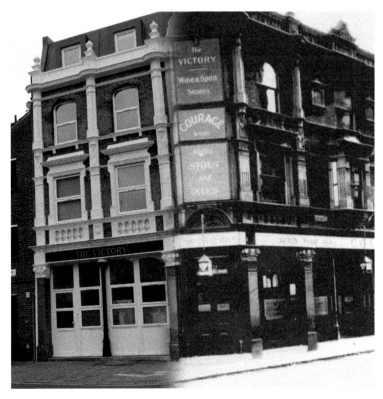

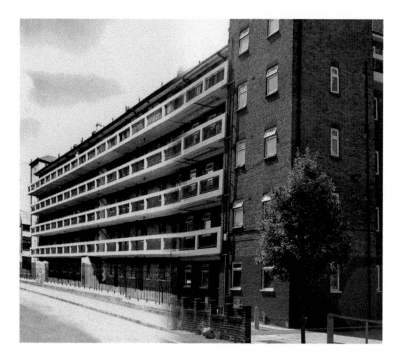

Comus House/Congreve Street

Situated near to East Street and the Old Kent Road, this is said to be the only Congreve Street in the whole of the UK. Comus House was home to many old locals, who have very fond memories of their time living there. The block once comprised of all social housing properties, but many of the flats are now available on the open market at an average price of £300,000.

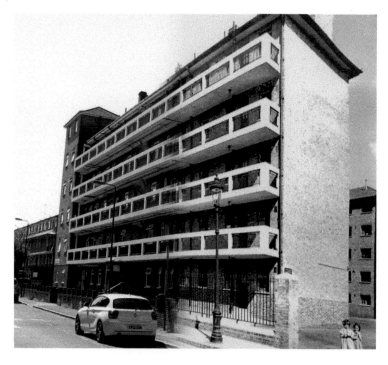

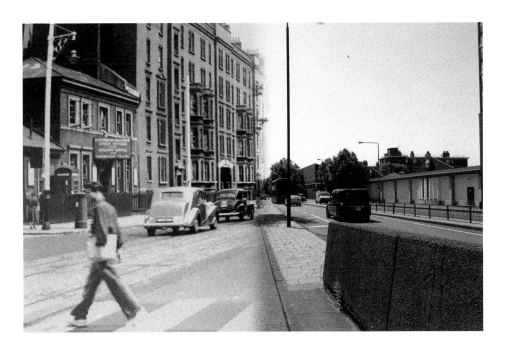

Bricklayers Arms/Old Kent Road

This is where the north end of the Old Kent Road meets the New Kent Road, and runs down to the Elephant and Castle, Great Dover Street and Tower Bridge Road. Old Kent Road is nearly 2 miles long and forms part of the A2, which joins London to Dover. The name Bricklayers Arms is a reminder of a coaching inn that once stood here, just one of many alehouses that has populated this locale over the past 600 years.

It is also the home of the famous/infamous (depending on your point of view) flyover, work on which began in 1967. To the left of both photos, you can see the Dover Flats, a large ex-Corporation of London housing estate.

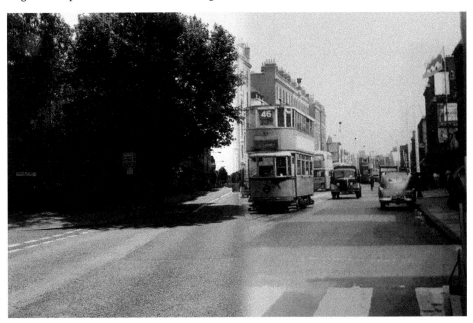

The White House

Situated at No. 155 Old Kent Road and built in 1800, this Grade II listed building was the home and office of well-known commercial architect Michael Searles (1750–1813). Built by Searles himself, its original ironwork survives. It later became the offices of the Rolls family trust estate. Charles Stewart Rolls of that family went on to form a partnership with Henry Royce and the rest, as they say, is history. The building today is home to the 'The Light of The World' church.

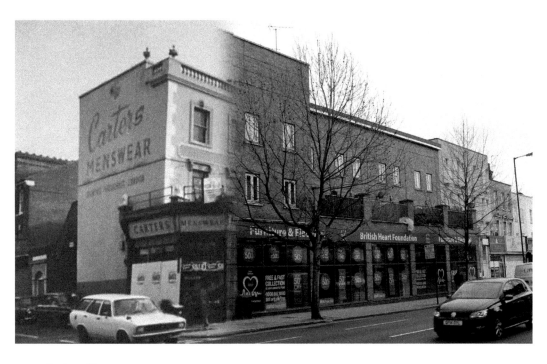

Carters Menswear

Nos 211–217 Old Kent Road used to be the site of George Carter & Sons, sellers of fine menswear since the 1850s. The clock above the main entrance used to have a bowler-hatted gent atop it; with his hat rising as the hour mark was reached! Carter's close down 1978 and today a British Heart Foundation charity shop stands on the site, from where second-hand furniture and goods can be purchased.

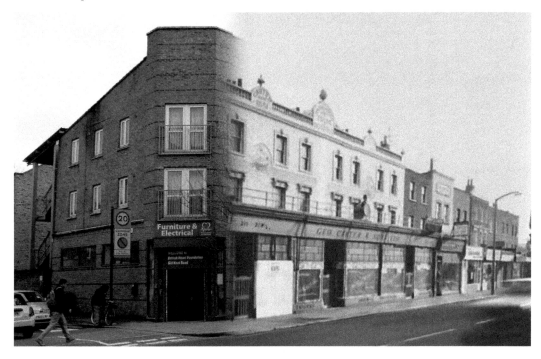

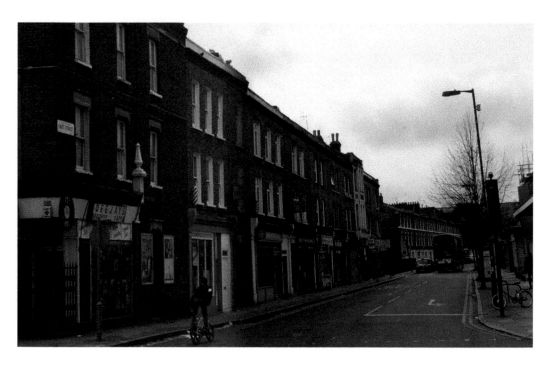

East Street I

The top end of East Street as it emerges on to Old Kent Road. It's good to see the decorative white finial still in place and the barber is still there as denoted by his 'blood and bandages' striped pole. In the second photo, there is a sighting of the 'lesser-spotted' 42 bus on its way to Camberwell Green.

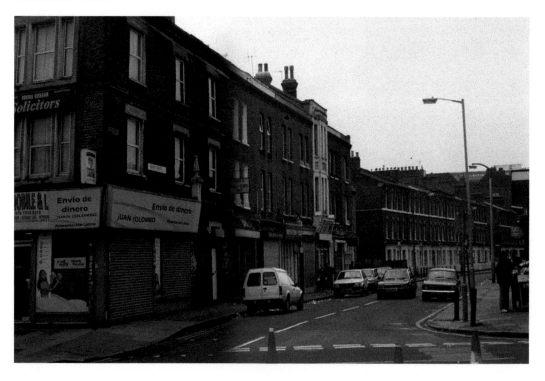

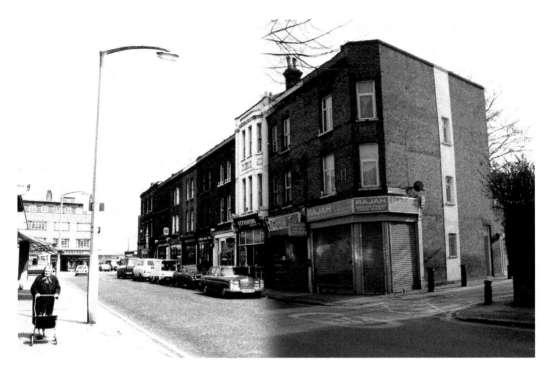

East Street II

Some new, some old, these businesses of East Street lead into Old Kent Road. The upper part of the buildings look remarkably similar today when compared to the 1970s sepia photograph. The eagle-eyed among you will have spotted the legendary 'Bert's' which will get a few mouths watering at just the mention of the name.

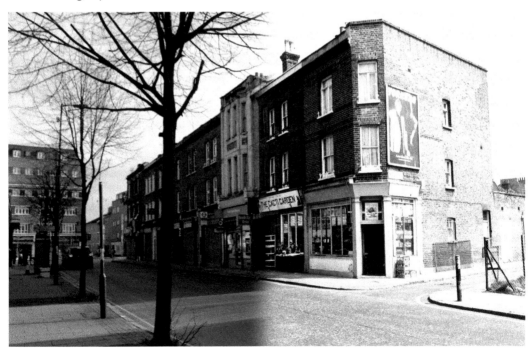

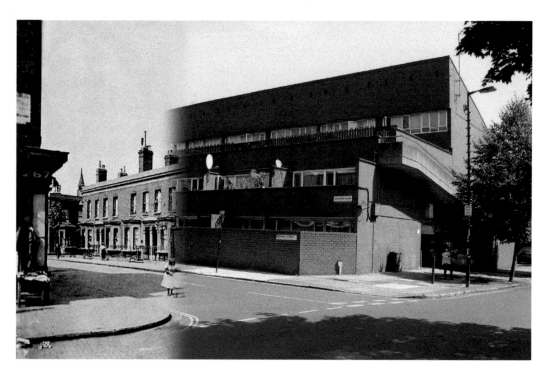

Bedford Arms/Beckway Street

Situated at No. 269 East Street, the Bedford Arms, once part of the Charrington Brewery, had a history going back to at least 1825 when Charles Hearden or Hearder was the landlord. The lovely old building survived until 1964, but there was no trace of it after 1974. The Eynsford House housing estate stands on this corner of Beckway Street today.

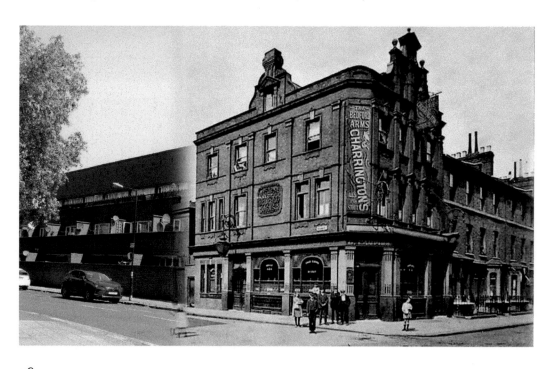

Exon Street

Many of the houses in this quiet backwater near to Old Kent Road have been renovated and restored in recent years. The authors were particularly pleased, however, to find the goal posts from the 1970s still there and ready for use – just.

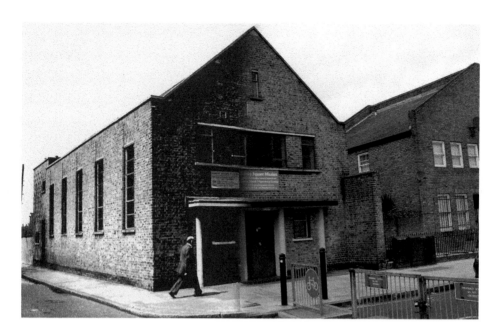

The Surrey Square Mission Hall

The preacher Charles Haddon Spurgeon was so popular in his day that the Metropolitan Tabernacle was built in 1859 to accommodate all those who wished to hear him speak. The building, with a capacity to 6,000 worshippers, still stands impressively directly opposite what was the Elephant and Castle shopping centre. A by-product of Spurgeon's popularity, the Surrey Square Mission was founded as an extension to the interest in his work. The building, tucked away not far from Old Kent Road on the corner of Surrey Terrace, has been used for many purposes over the years, including hosting the local Boy Scouts meetings and its continued use today as a Sunday school.

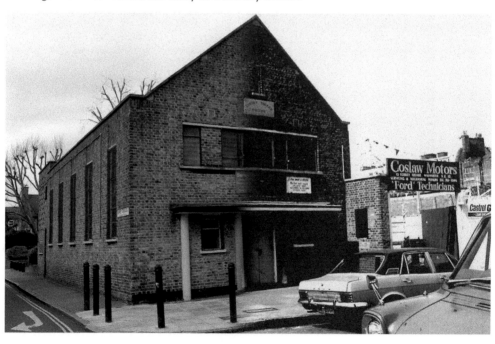

Aldridge Street

The connecting image between these two photographs of Aldridge Street is of course the Aylesbury Estate, looming large in the background. One-time streets full of decent terrace housing stock were later demolished to make way for new builds, like the Kingslake Estate shown here, on which work began in the late 1940s and which was designated as public housing.

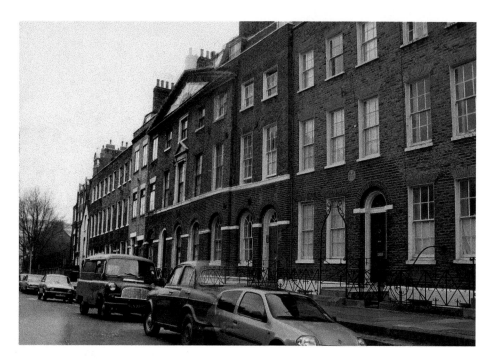

Surrey Square I

Michael Searles (1750–1813) was responsible for the design of the housing stock here, and he was also a favoured surveyor for the Rolls Estate, which began in 1775. John Rolls, a cow keeper, rented 10 acres south of Old Kent Road. Gradually he acquired other valuable land locally and in nearby Bermondsey. His descendants included Baron Llangattock, the father of Charles Stewart Rolls, who began the partnership resulting in the Rolls-Royce Company being formed in 1906. From local acorns...

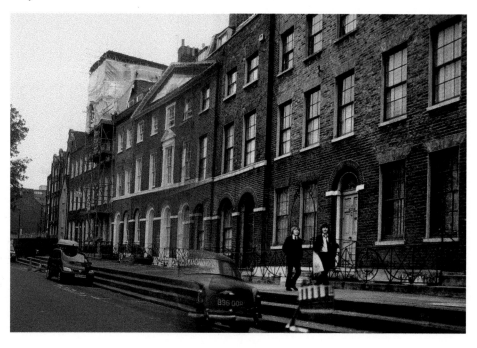

Surrey Square II

The road sweepers of 1964 give way to the courier bicycles that have been such a familiar site in 2020 and 2021. The backdrop is a fine selection of Georgian terrace houses designed by surveyor Michael Searles and built between 1795 and 1796, eighteen of which have survived. The buildings today still have their original torch snuffers and iron railings, plus the 'four-kerb' pavement, which is always an interesting feature. The fan motif pediment in Coade stone above the end pavilion is another original surviving detail. Samuel Palmer, the well-known landscape artist, was born at No. 42 (formerly No. 13) in 1805.

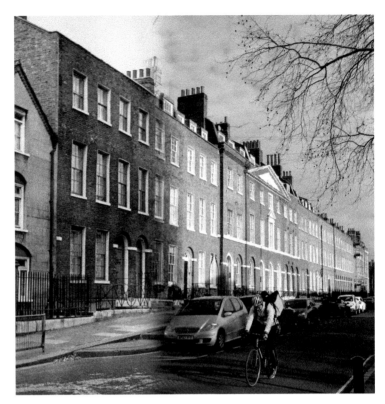

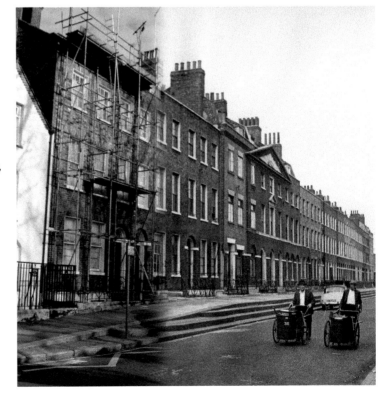

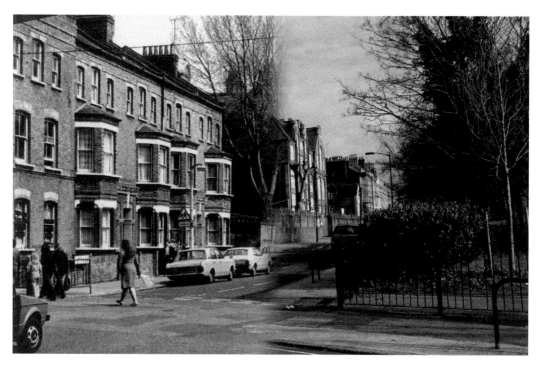

Alvey Street I

Many of the local houses that have survived are now selling for approaching a million pounds. Meanwhile, huge housing estates that many similar homes were demolished to make room for have been built and demolished in the same time frame. Lessons learnt? Only time will be the judge of that.

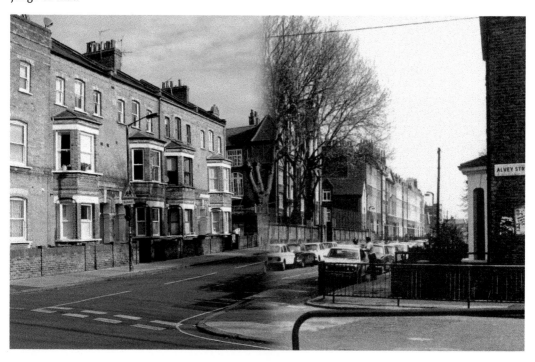

Alvey Street II

Alvey Street runs up the edge of the Wolverton block on the vast Aylesbury Estate. Construction of the Aylesbury began in 1963 and the eventual 2,500 flats housed over 10,000 residents. It is currently being demolished and rebuilt, and will be lower rise in style.

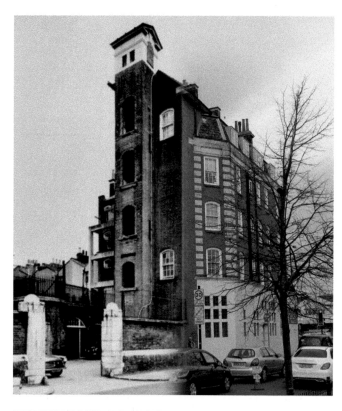

Old Kent Road/The Blue Mantle

The London City Fire Brigade opened a station on the Old Kent Road in 1868. A new station was then opened here at Nos 306–312 under the auspices of the London Fire Brigade. They then moved on again. This left the station that you can see here empty for a few years. That is until the Blue Mantle fireplace and antiques company moved in. Established in 1969, it is the largest showroom of vintage, antique and replica fire surrounds in the world.

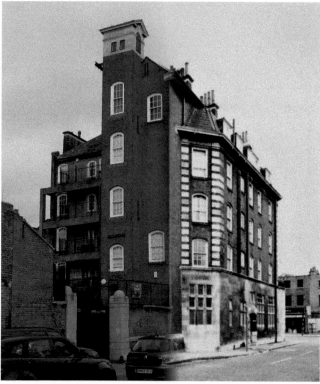

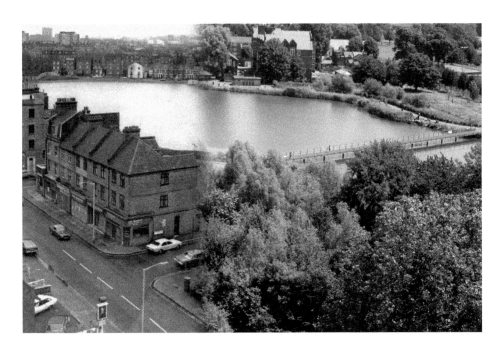

Burgess Park

The planning for compulsory demolition of old housing stock and factories started as far back as 1943 and eventually led to this 13-acre site named after the area's first lady mayor, Jesse Burgess. Some buildings survived the bulldozer and remain part of the site, namely the almshouses and Passmore Edwards library and public baths and washhouses. The lake was built in 1982 and contained 12 million gallons of water and 11,000 fish. There is a fishing club situated on the eastern side with the smaller part of the lake being purely ornamental and home to many breeds of duck and other birds. A walkway bridge divides these. The park underwent renovation in 2011 and is now fully open once again with new planting areas, lighting, and many areas of sporting facilities.

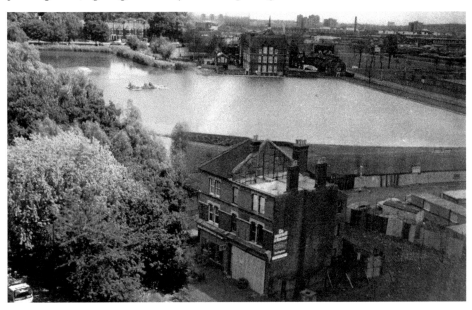

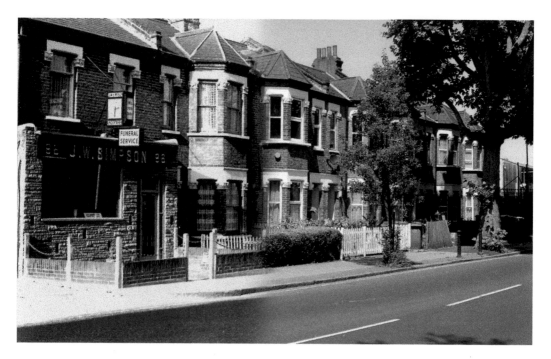

Albany Road

Currently standing at No. 96 Albany Road is Dignity Funerals Ltd, which owns over 800 other funeral locations in the UK. For many years, however, this was J. W. Simpson, a firm run by a local Camberwell and Walworth family. Joseph Wade Simpson is listed as an undertaker from as early as 1871.

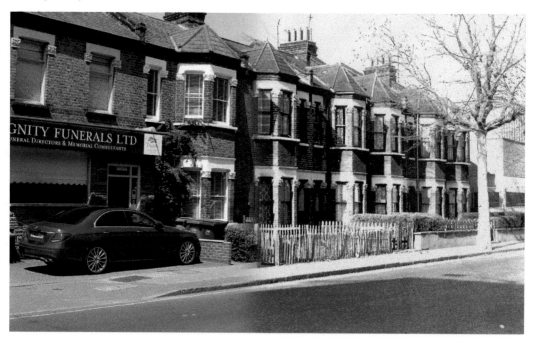

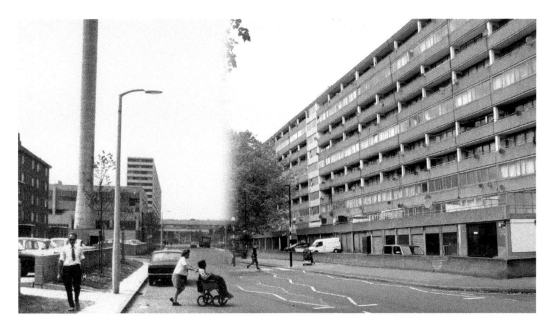

Thurlow Street

We're looking down towards the Elephant and Castle and New Kent Road in this photograph, taken from the Albany Road end of Thurlow Street. The large tower blocks of the Aylesbury Estate loom menacing large to the right of the photographs. Note the saplings that are now fully grown trees and the abundance of satellite dishes, which would have been considered science fiction as home use at the time the sepia photograph was taken. In just a few short years this will be a changed landscape once again as the remainder of Aylesbury Estate is demolished for the new builds planned for this part of Walworth.

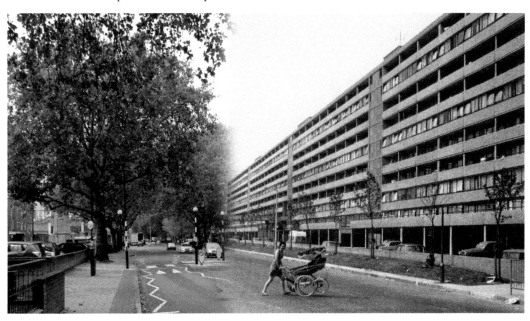

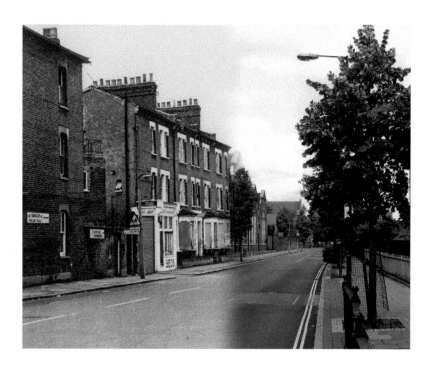

Flint Street

Running down towards Rodney Road, you can see the dramatic transformation of the old Victorian streets into the new builds of the last few years. Further down on the left you can pick out the distinctive red brickwork of what was once Flint Street School, which was opened in 1875 and is now called English Martyrs RC Primary School. It is Grade II listed and contains fine decorative cut brick and terracotta detailing.

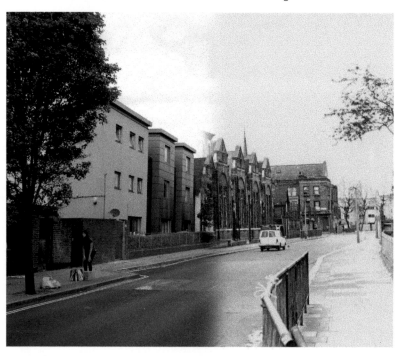

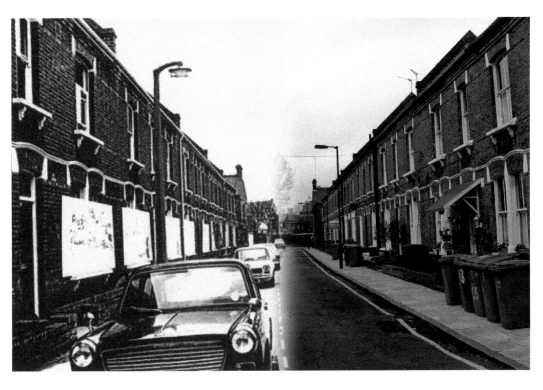

Tisdall Place
The future didn't look too bright for the houses in the older photograph of the 130-metre-long Tisdall Place, which was taken in the mid-1970s. But as you can see in 2021 version, the houses survived with original features, the window ledges for example, intact.

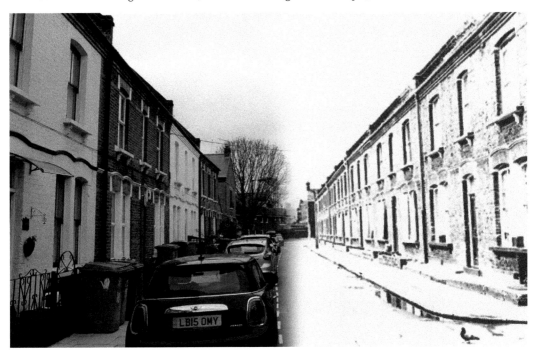

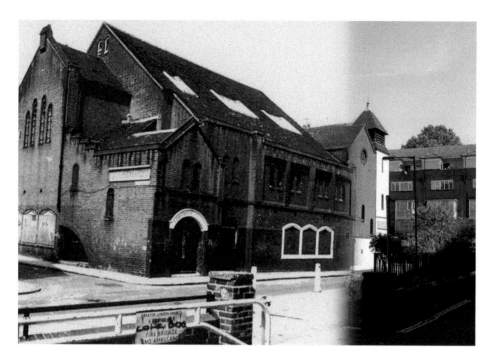

Pembrook House

These buildings are a rare example of an 'Oxbridge' mission from the nineteenth century. Founded in 1885 by the students of Pembroke College, Cambridge, it houses St Christopher's Church, which is now Grade II listed. The community side of Pembroke House is as strong as ever, and during the recent Covid-19 pandemic, the building became a food distribution hub, delivering supplies to 1,500 people a week.

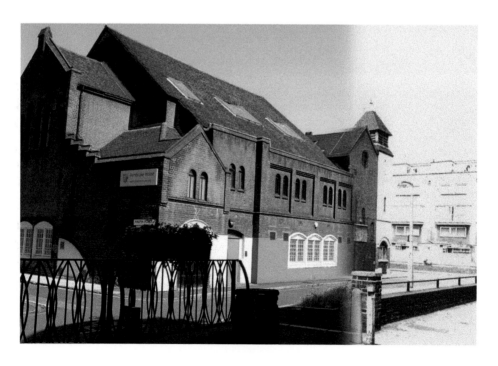

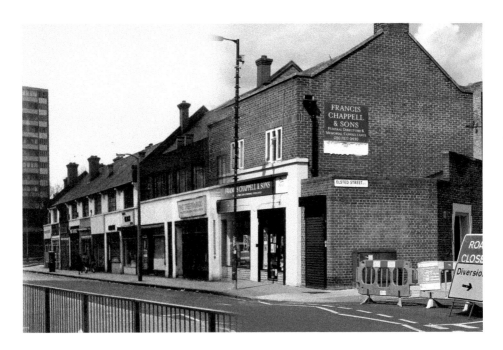

Francis Chappell & Sons

Situated at No. 239 East Street, the family within the Francis Chappell funeral directors company have a history of funeral service going back as far as 1840. Today, it has twenty-five funeral homes across South East London. Previously these premises were home to H. W. Simpson funeral directors, itself a long-established family firm with roots going back four generations, some of whom continue in the trade under the company name of T. Allen. This is named after Terry Allen, who began his career with Francis Chappell and who married Lynn, whose family were from the H. W. Simpson dynasty.

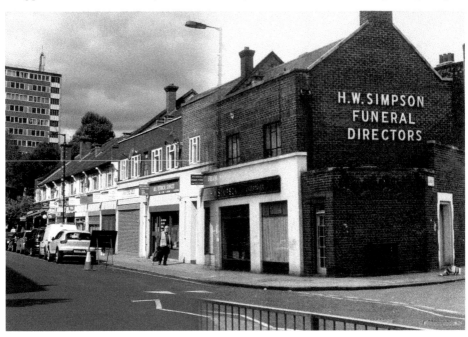

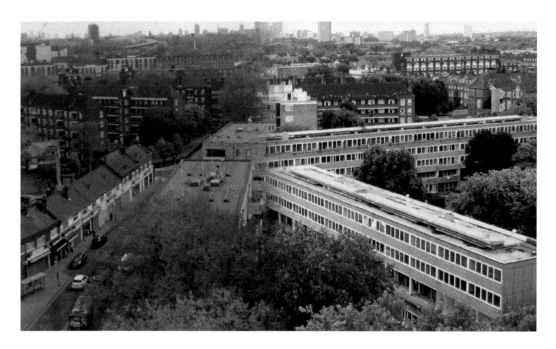

The Aylesbury

The Canary Wharf skyline can be clearly seen in the background of these photos taken from high up on Taplow House on the Aylesbury Estate. This shows how close to the centre of London the area of Walworth actually is. The rebuilding and regeneration has carried on pretty much all the way through the various lockdowns, and now continues at a pace, when we see yet another huge structure gradually disappear, replaced by an army of builders laying down the immediate future of Walworth.

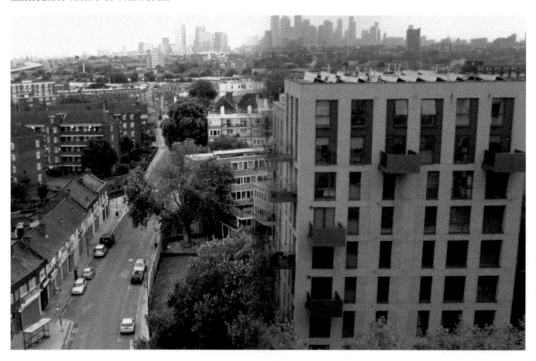

Naylor House

Constructed in the 1950s, Naylor House stands on the corner of East Street and Flint Street. This area was once teeming with people, especially at weekends, for many years right up to the mid-1990s, what with them coming and going to and from East Street market and Old Kent Road, which is just a little further on to the right of these images. Both of those thoroughfares were the very lifeblood of the area.

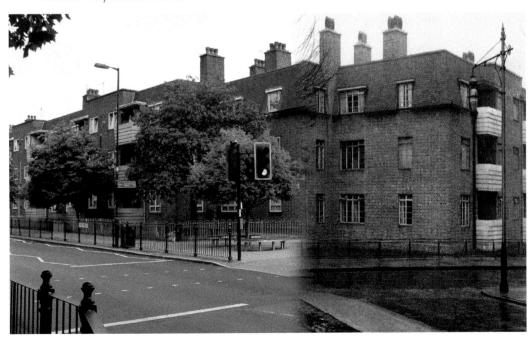

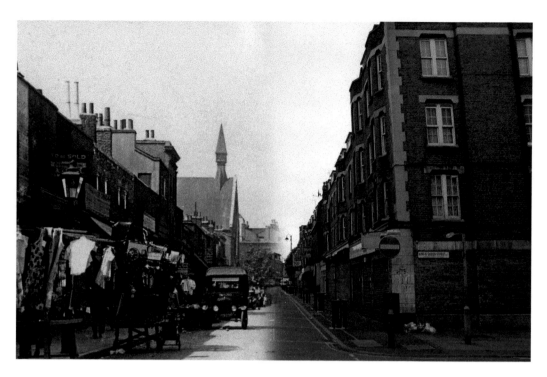

East Street III

There has been official trading here in what is locally known as 'The Lane' since 1880, although records state there has been street trading since the sixteenth century in this part of London. Regular pitches were designated in 1927 and the market would be heaving with punters on a Sunday for many a year. In recent times, there has been a decline in the number of stalls, but the market carries on – long may that continue.

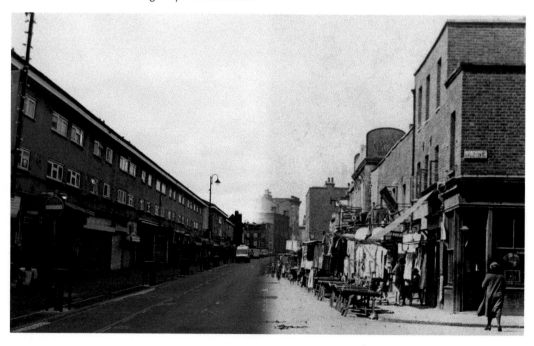

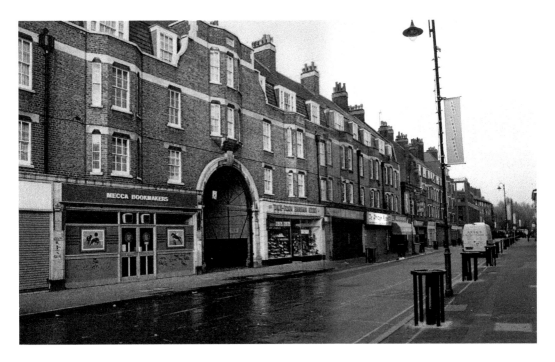

East Street IV

The older photograph shows East Street in the 1970s. The street and therefore the market have struggled in recent years. Competition from local 'pound shops' and online shopping has dented it commercially. The building with the large arch, dominating these two photographs, is the Pilton Place Estate. Built in 1933, it was purchased and then modernised from 1971 by the Peabody Trust. The trust was set up by American and social reformer George Peabody, with his first estate was opened in 1864 in Spitalfields, East London. Today they have over 70,000 residents.

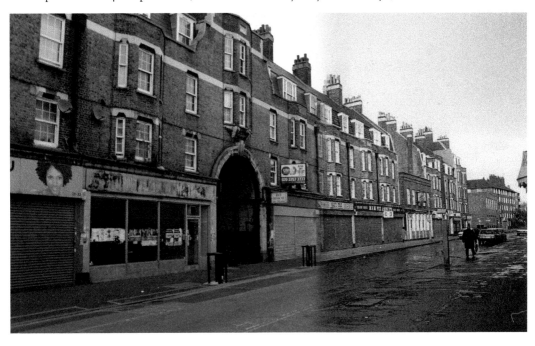

East Street V

Here we revisit a couple of much loved shops. The A1 stores was opened locally in 1912 and also had larger premises at No. 281 Walworth Road. They sold albums and singles at each location, as well as household lighting and greeting cards. The shop also proved to be a very popular meeting place for the teenagers of the 1960s. It finally closed its doors for good in 2008. Rainbow sold good quality shoes and clothing. The 'ghost sign' of the shop sign is still visible on the frontage of the now empty unit.

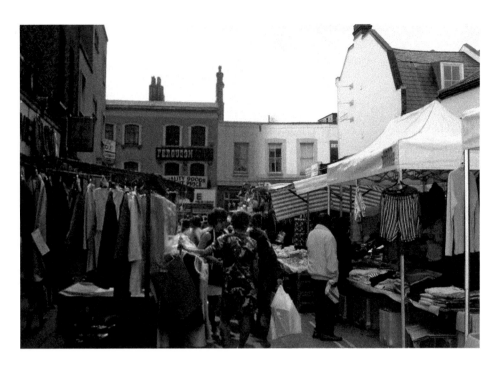

East Street VI

The photograph from the early 1970s shows the hustle and bustle of this famous old street market. Buying and selling of all sorts took place and everyone knew someone who worked down there. This end of it, near to the Walworth Road, is said to be the birthplace of the one and only Charlie Chaplin, signified by a blue plaque erected above the shops on the left. Things here are a lot quieter now, but trade continues, and who knows, with the constant regeneration of the area of SE17, 'The Lane' may yet again regain its former glories. Your authors distinctly hope so.

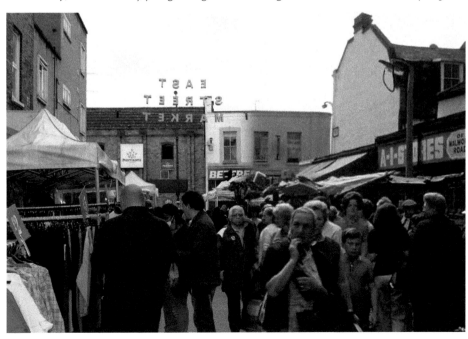

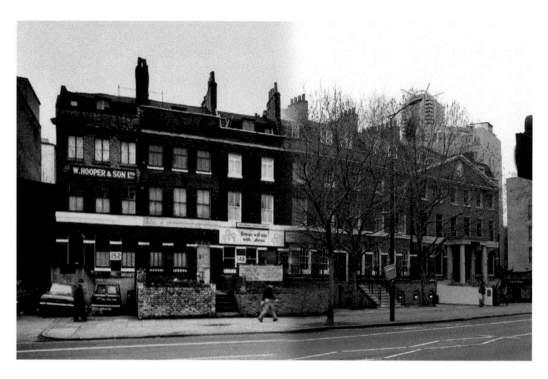

The Manor Pub

Bucking the trend of pubs closing all over SE17, here is the story of a pub actually opening. It is situated within in the impressive Grade II listed building to the far right of the photographs at No. 140 Walworth Road, once the HQ of the Confederation of Ship Building and Engineering. In April 2018 after years of standing empty, The Manor pub was opened. Specialising in craft beers, it has proved popular with a good mix of new and old Walworth inhabitants.

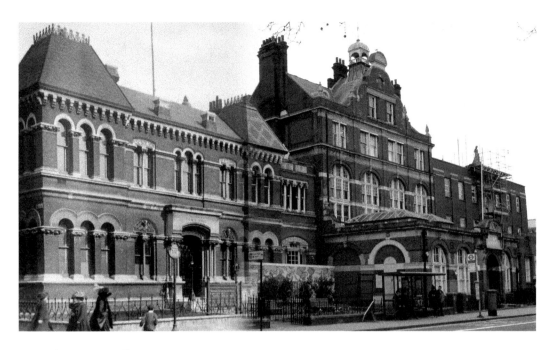

The Vestry Hall

No one who saw this famous old building engulfed in a fire in 2013 will ever forget it. Thankfully it was saved, though it suffered extensive damage. Designed by Henry Jarvis, it was opened in 1865 as the Vestry Hall of St Mary Newington. The Newington Public Library was added in 1892 and it was renamed Southwark Town Hall in 1900. New premises were found when the London Borough of Southwark was formed in 1965 and this building became home to the local registrars and council offices by and large, becoming known as the Walworth Town Hall. The Cuming Museum, which specialises in local history, moved in in 2006. As a result of the fire, the building was added to the Heritage at Risk Register. Restoration work still continues.

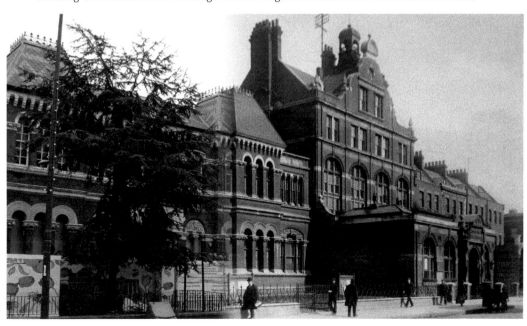

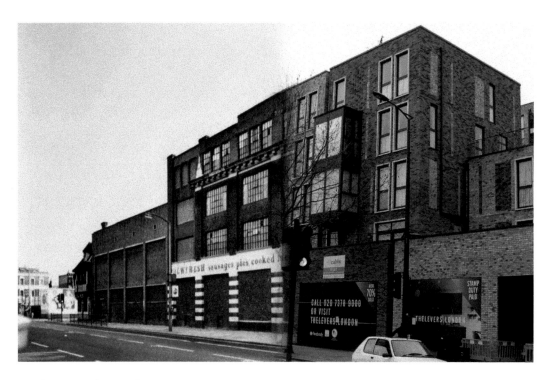

Dewhurst Butchers Ltd

Here at Nos 154–179 Walworth Road the London depot of Dewhurst the butchers once stood, with its factory below and offices above. The company became one of Britain's richest business dynasties and the world's largest retailer of meat. It also got caught up in well-remembered tax avoidance scandal. The company entered administration in 1995. In 2019, the building began life as 'The Levers', a new housing development by the Peabody Company.

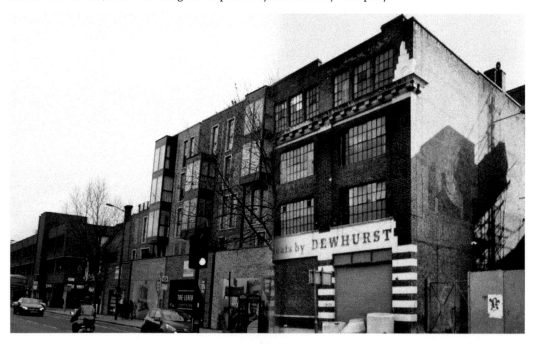

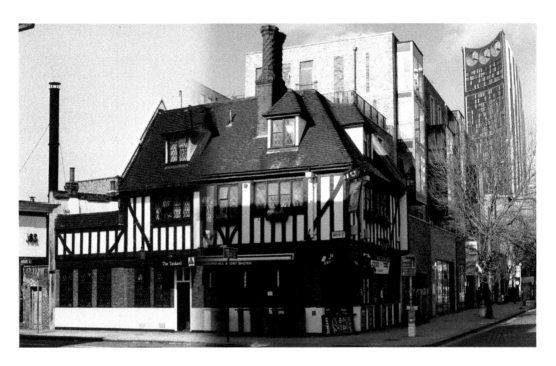

The Tankard

The mock-Tudor frontage is instantly recognisable to all who travel up Walworth Road. The other well-loved features are the red-brick latticework chimneys. This was once the destination of choice for many a wedding reception, after the matrimonial ceremonies were completed across the road at the old Town Hall. Its future has been in doubt a few times in recent years, but it is once again in the hands of a previous owner and was doing okay before Covid-19.

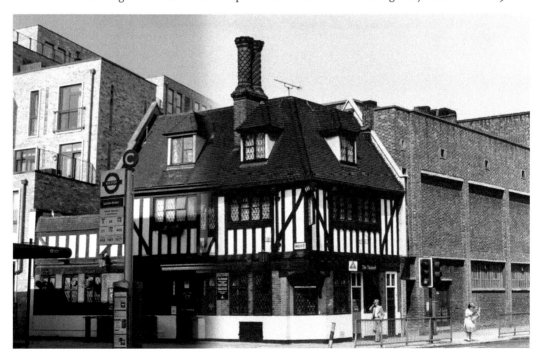

Herbert Morrison House

Situated at No. 195 Walworth Road, on the corner of Browning Street, it was the Robert Browning Settlement from 1895, with legal and medical advice being offered from here for the poor of the area. Herbert Stead, a social campaigner and an important figure in the establishing of the old age pension in 1908, founded the Settlement. The building was also once the HQ of the London Labour Party. It was named Herbert Morrison House in honour of one-time Deputy Prime Minister Herbert Morrison, who was born in Lambeth. His grandson Peter Mandelson was in the cabinet for both Labour prime ministers Tony Blair and Gordon Brown. No. 195 is currently home to Kensington UK Lawyers.

Chatelaine House

Covering Nos 182–202 Walworth Road, the long red-brick building you can see is Chatelaine House, once home to offices of Southwark Council. The fascinating photograph, which dates to the early 1970s, show what was replaced. Forty years on, all the shops have all gone or been relocated, except McDonalds, and this entire building is ready for demolition. Newer shops and seventy-seven flats are planned to take its place. McDonalds, it is thought, will be staying locally.

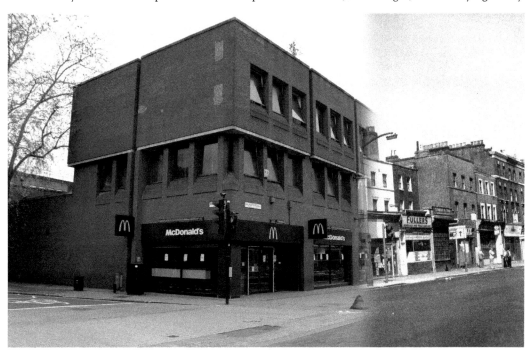

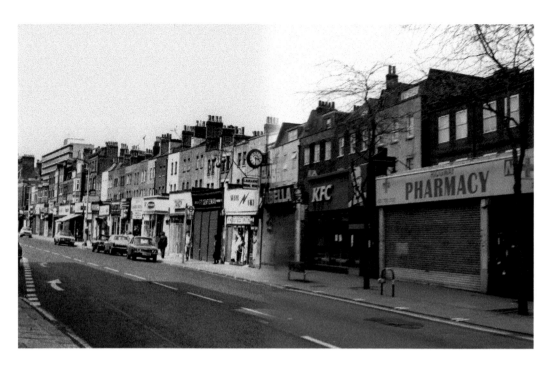

Walworth Road I

The main thoroughfare of the area is the Walworth Road. Goods have been sold here since the early nineteenth century, whether off a barrow or from one of many retail units that line it on both sides. Some shops have been longstanding, such as Marks and Spencer and Boots, with others just lasting a few months.

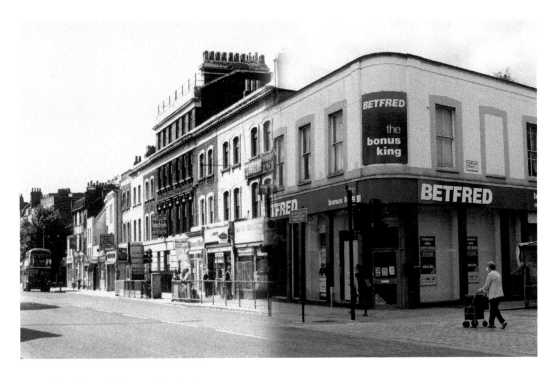

The Horse & Groom/Betfred

There is an entry for a Horse & Groom standing here or nearby at No. 262 Walworth Road as far back as 1811. Since closing in the very early 1990s, the site has been a Woolwich Building Society and at the time of writing is currently a Betfred betting shop. Opening with a single shop in 1967, Betfred had over 1,650 premises by 2017.

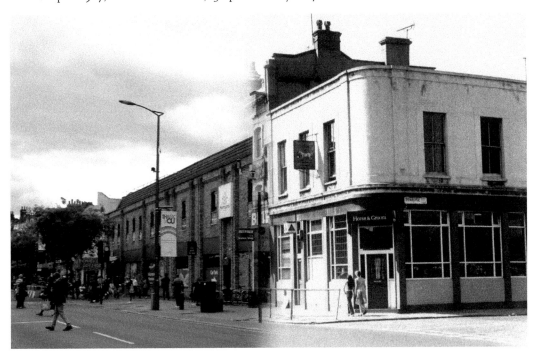

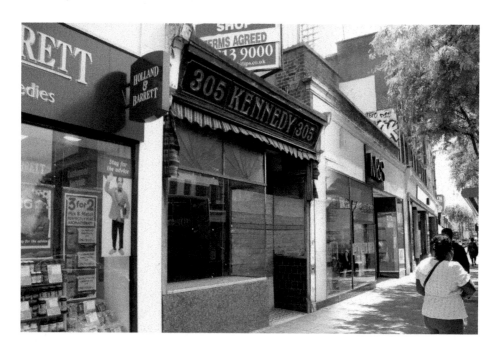

Kennedy's

Opened *c.* 1923, this was a very popular local food supplier. Kennedy's started on Rye Lane, Peckham, in 1877, eventually setting up HQ at No. 86 Peckham Road. They were famous for their fine quality sausages, pies, sausage rolls, bacon and cooked meats in general, as well as cheeses among much more. Deaths among the older members of the family meant it all came to an end in late 2007. This Grade II listed building at No. 305 Walworth Road has been used as a café and a Chinese noodle bar in recent times. It is currently empty. We're pleased to say that many of its original features remain intact.

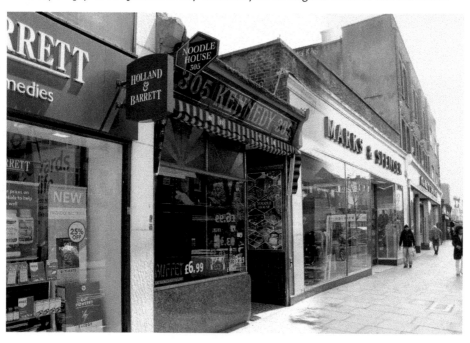

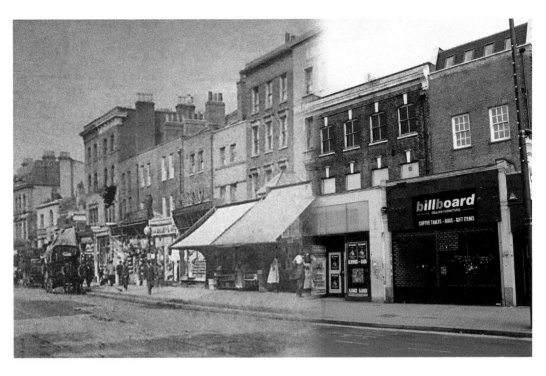

Sir William Walworth

A long-standing Ind Coope pub, named after Sir William Walworth, who was Lord Mayor of London, not once, but twice. His other claim to fame was for killing Wat Tyler, the leader of the Peasant's Revolt, which began in 1381. The pub was opened in 1869 at Nos 297–299 Walworth Road and closed *c.* 1989.

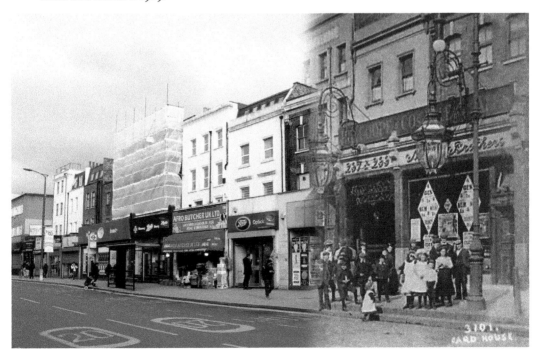

The Beehive

The Beehive Pub, situated at Nos 60/62 Carter Street, is very popular with a fine reputation for its food. It also has an interesting reputation, especially for cricket lovers. In 1796 the newly formed Montpelier Cricket Club played their first match at the Montpelier Tea Gardens in Walworth, moving in 1808 to The Beehive Tea Gardens that this pub once looked out onto. The club remained there until 1844 when property developers purchased the land and it moved to the Kennington Oval, then a market garden owned by the Duchy of Cornwall. Thus, members of this gentlemen's cricket club were instrumental in forming what is today known as Surrey County Cricket Club.

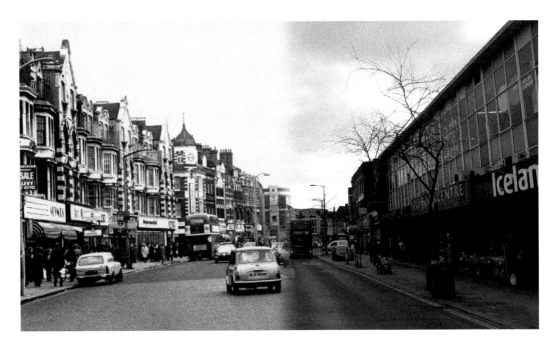

The Walworth Road II

Looking towards Camberwell, the highly ornate buildings from 1908 on the left are the standout feature on both of these photographs. Thankfully they have survived and are now private dwellings in the main. To the right of the photograph above what was the Co-Op is now The Gym and a combination of Peacocks, the Oli Food Centre and an Iceland on the lower level. To the left, once stood Guvnors, a popular gentleman's fashion shop, and Art Wallpapers. Superdrug remains in this parade of shops today. The clock, which is on top of the old Harvey and Thompson jewelers and pawnbrokers, is still in place.

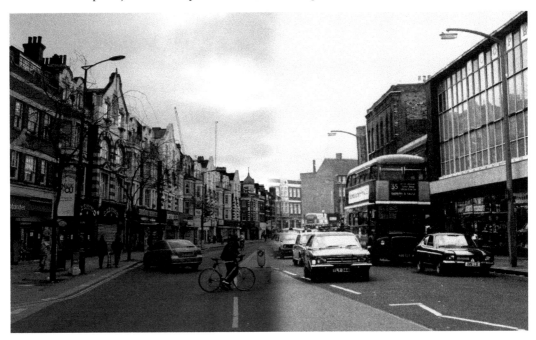

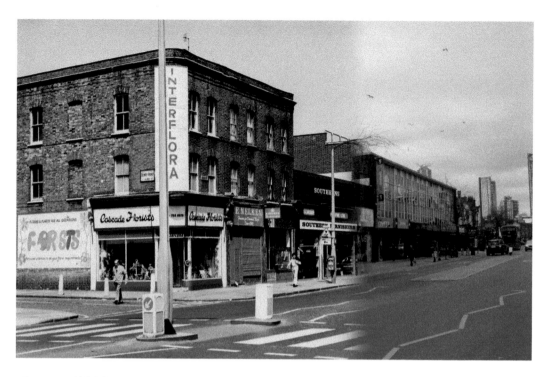

Olney Road/Fielding Street

No. 354 was once home to 'Cascade Flowers', a long-established and much loved local business. It is seen here on the corner of what was once Olney Road, and which is now called Fielding Street. At the premises now we have Figaro Barbers, though the slowly fading very 1970s wall painting of the word 'florist' from 'Cascades' time can still be seen. Southern Furnishers is now Nova Furniture.

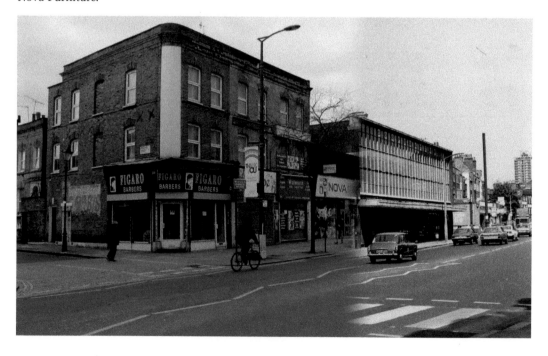

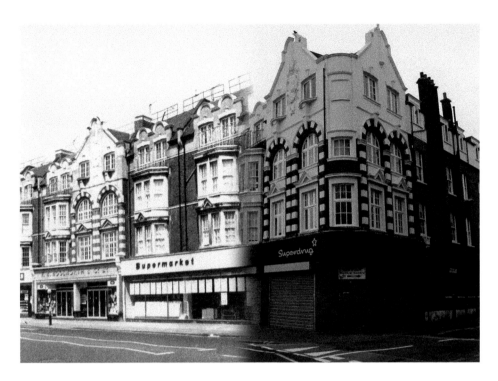

Woolworths

Our focus here is on Nos 367–369 Walworth Road and what was once a very familiar sight on the high streets of the UK. Woolworths opened their eighty-second store here in 1919. This one remained in operation until 1990. The company completely folded to genuine astonishment, with all shops closing in early 2009.

Acknowledgements

Mark Baxter

I dedicate my work in this book to my dear old mum, Jean Baxter, who died in March 2020. She was a Camberwell girl from start to finish and is badly missed each and every day. I owe you everything, mum.

And I would like to give a huge thanks to Dave Miller, an old Walworth Road boy, who moved to Kent but carried the 'manor' in his heart till the end of his life in October 2021. Dave kept in in touch regularly and loved this series of books on SE17. I also send kind regards to his daughter Elaine.

Darren Lock

I dedicate this book to my sister Diane, who is a Walworth girl through and through.

I would also like to dedicate it to Aunt Millie, Aunt Rene and Uncle Len, my cousins Tony and Joanne Thumwood, and Trevor and Diane Pheby, who still live, eat and shop in Walworth today.

It is also for my late cousin Johnny Pheby, who was a big influence in my life and shared the same love of the history of Walworth.

And not forgetting baby Stevie-Anne Elizabeth Green, a Walworth girl forever.

Toodle pip, arrivederci and be lucky.

The authors would also like to thank the photographers of the past who captured the views we have used. They also thank the community of Walworth for once again supporting two of their own in the past eighteen months.

Trust us that is never taken for granted. Viva SE17!

George Dyer – A Cut Above the Rest

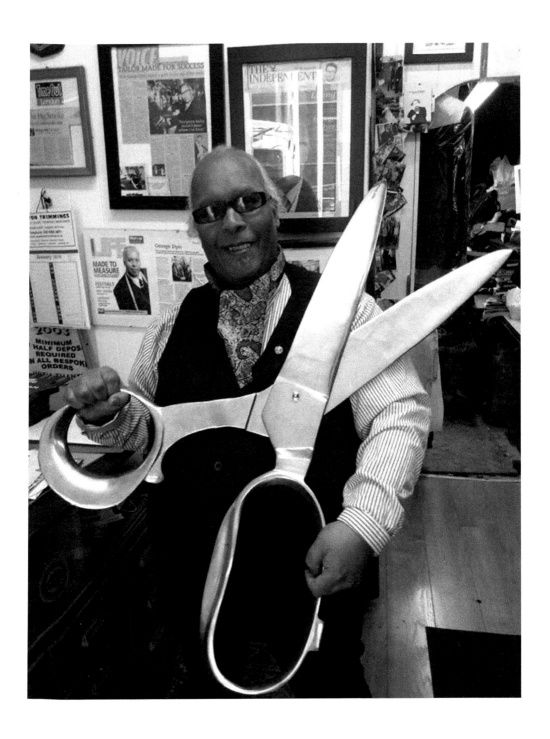

The outpouring of love upon the announcement of the death of local bespoke tailor George Dyer was all anyone needed to know about the man. He was simply loved by all walks of life, from every background.

In the best part of thirty years working at his shop at No. 187a Walworth Road, he'd had all sorts walk through his door. Pop stars, radio broadcasters, film stars, numerous film crews and hundreds and hundreds of normal, everyday people, who he then proceeded to treat like pop stars and film stars. 'All my customers are celebrities to me' he was known to say almost daily.

Born in Jamaica in 1955, he arrived in the UK aged four. George gradually developed up a love of clothes and by seventeen he was working for a variety of high street tailors all over London, honing his craft both in-store and at the London College of Fashion, where he studied on day release for three years.

Once qualified, George eventually took on the lease of the old 'Ron Martin' shop at No. 187a Walworth Road in 1995. There had been previous tailors in situ there for many years and George was keen to carry on the 'art of bespoke' at the premises, under his own shop name of 'The Threadneedleman'.

His motto was 'Nulli Secundus' – second to none. George was known to often work into the small hours of the night to finish a garment. He rarely took a day off and gradually, as he got older, all that took its toll on his general health. He soldiered on, of course, as he was in love with what he did for a living. This wasn't work to George, this was love.

He seemed to be always there, a permanent fixture on the Walworth Road.

So, losing him like we did on the 28 March 2022 was a massive shock to many.

SE17 miss him terribly.